SECRET
DOVER

Jeff Howe

AMBERLEY

Acknowledgements

My thanks to Paul Wells, Keith Parfitt, Jon Iveson, Victoria Friedrich, Kerry Chapman, Paul Hewlett, Josie Sinden, Richard Linzey and Colin Varrell for pictures, advice and favours. Most importantly thanks to Kerrie Rouy for her love, support and very candid proofreading.

First published 2019

Amberley Publishing
The Hill, Stroud
Gloucestershire, GL5 4EP

www.amberley-books.com

Copyright © Jeff Howe, 2019

The right of Jeff Howe to be identified as the
Author of this work has been asserted in accordance
with the Copyrights, Designs and Patents Act 1988.

ISBN 978 1 4456 8563 2 (print)
ISBN 978 1 4456 8564 9 (ebook)

British Library Cataloguing in Publication Data.
A catalogue record for this book is available from the
British Library.

Origination by Amberley Publishing.
Printed in Great Britain.

Contents

1. 'One's Personal Dover'

Dear Reader,

If I may start this preface with a quote from one of my favourite Dover tour guides, William Batcheller, who in 1828 published his *New History of Dover*: 'In this concise history it is intended to comprise, within a narrow compass, whatever may be found most interesting relative to the Town and Port of Dover.'[1]

Batcheller's guide carries on for more than 360 pages as he tries to shoehorn in what he thought were the most interesting facts about his home town. However, the subject matter that Batcheller thought was of the utmost interest, I may not, and indeed you may not either. That is because we all have our own personal Dover.

I'll give you an example. Take Reginald Foster, a London journalist based in Dover during that miracle called the Evacuation of Dunkirk in 1940. In his 1941 book, *Dover Front*, there is left little doubt that his personal Dover was the brave men of the British Expeditionary Force who returned home in that myriad of 'Little Ships':'These were the Cockneys, the suburbanites, the men of the shires, men from Scotland and Wales ... that many came home at all was due to their grit and determination... in spirit they were unbeaten, and as I saw them, completely unbeatable.'[2]

What is your personal Dover? Perhaps you're a Shakespeare fan and your favourite place is that famous spot:

> There is a cliff, whose high and bending head
> Looks fearfully in the confined deep.

Or maybe your personal Dover is all about foreign travel – perhaps Evelyn Waugh's *Vile Bodies* is more to your taste: 'Lord, I shall be glad when we get to Dover...' After Miss Runcible suffers the embarrassment of the customs officers, 'I can't tell you the things that have been happening to me in there. The way they looked, too, too shaming. Positively surgical, my dear...'[3]

My friend William Batcheller's personal Dover was published for all to see, but probably, like you, I prefer to keep my personal Dover to myself, my secret Dover, if you will. I hope you enjoy reading *Secret Dover*, and when you have time, please do let me know what your secret Dover is.

<div align="right">

Yours sincerely,
Jeff Howe, May 2019
jeff@secretdover.co.uk

</div>

1 Batcheller, 1828, p. i.
2 Foster, *Dover Front*, p. 20.
3 Waugh, E., *Vile Bodies* (Penguin, London, 1996), p. 15, 20.

2. 'The Western Heights' (Admission by Pass to be Obtained from Headquarters, Dover Castle)[4]

The Dover Castle we see today is not the same castle our ancestors would have seen. If we go back around ten to twelve generations to the 1780s, the ensuing two decades would see building works and alterations to the very fabric of the castle that would transform it from what was still essentially a medieval castle into a modern artillery fort. The man responsible for these changes was Lieutenant-Colonel William Twiss (1745–1827), who was the Royal Engineer in charge of works at Dover during this period. With Napoleon Bonaparte just 23 miles away across the Channel, it was Twiss' job to make the south coast secure against invasion, and he did this by modernising the castle and creating two forts on the Western Heights. At the castle he despoiled much of the medieval architecture including many towers, banks and walls to create gun batteries, bombproofing and casemates. To mention just a couple of examples of Twiss' many works at the castle: Canon's Gate was a simple sally port set in the medieval curtain wall, but Twiss transformed it into a main entrance with adjacent casemates

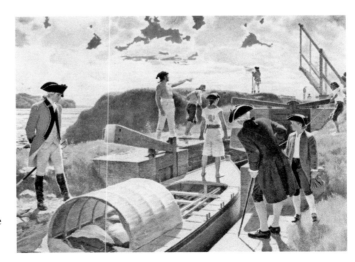

The Royal Engineer William Twiss overseeing the building of a lock in North America in 1778 (1961).

4 Chapter titles are opening sentences and captions from a 1930s Ward Lock guide to Dover.

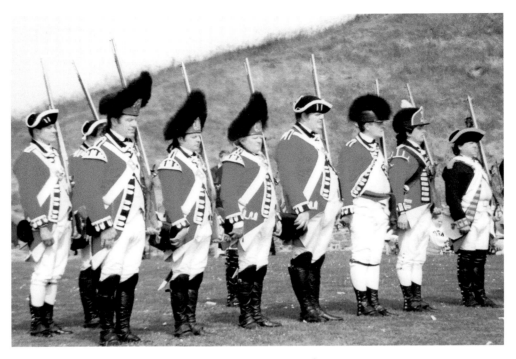

Re-enactors as North American colonial troops at Dover Castle, 1999.

(which can be seen on the right as one drives through Canon's and enters the site).[5] Another example of Twiss' work is the redan at the northern end of the castle, which is the large brick arrow-shaped building at the far end of the underground works that overlooks the Deal road.

Although much changed today, Twiss effectively built the Citadel, the Drop Redoubt and also the famous Grand Shaft triple helical staircase. What is not generally known about the defences on the Western Heights is that they were started during the American War of Independence (1775–83), and that Twiss adapted and improved them over twenty years later to counter the Napoleonic threat. The defences on this side of Dover were much more rudimentary during the American War, and were built during the late 1770s when there existed a threat of invasion from the Netherlands, France and Spain, all of whom were at this time allied to the revolting American colonies. These were just earthworks with timber revetments, rather than the vast brick-lined ditches with which we are now familiar.

Arguably, the key turning point of the American War was the surrender of the British army under Lieutenant-General John Burgoyne at the Battle of Saratoga in upstate New York in October 1777. It was this disaster that finally convinced the French Foreign Minister, Comte De Vergennes, to enter into an alliance with the Americans. Since the Treaty of Paris in 1763 following the Seven Years War (1756–63) France and Britain had

5 A sally port is an opening in a curtain wall that troops can exit in order to engage the enemy.

each seen themselves as the supreme power in Europe and North America. The British surrender at Saratoga helped to convince the French that they ought to take advantage of Britain's bad fortune and ally with the Americans. France signed a formal treaty of alliance with the new United States on 6 February 1778, and as the war fought on they supplied the Americans with arms, ammunition, uniforms, troops and naval support. In April 1779 Spain joined the alliance, part of the agreement being that France promised to help Spain recover Gibraltar from Britain.

On the road to Saratoga as it were, one of the British strategic objectives was the recapture of Fort Ticonderoga, a point around 170 miles north-west of Boston, Massachusetts. Originally built as Fort Carillon by the French in 1755 on a strategic river route between New York and Canada, the fort changed hands numerous times before hostilities were over. The fort had an inherent flaw in its positioning, which was that it was overlooked by two hills, Mount Independence and Mount Defiance, the latter known to the British as Sugar Hill. Sugar Hill was just 1,400 yards from the fort and was some 800 feet high, dominating both the other two positions. On 4 July the then Lieutenant William Twiss accompanied by Brigadier Fraser trekked to the summit of Sugar Hill, and realising its strategic position, Twiss proclaimed its suitability for mounting a gun battery there to lay siege to Fort Ticonderoga. The next day Twiss and his men, numbering around 400, started cutting a path 16 feet wide and 9 miles long up to the top of Sugar Hill. The route up the hill was almost perpendicular, and this was followed by teams of cattle pulling up two 12 pounder pieces of artillery with which to besiege Fort Ticonderoga. However, the

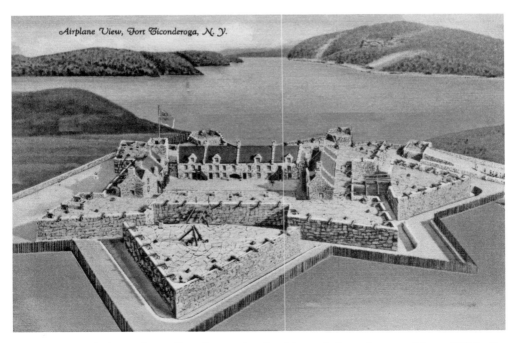

An artistic aerial photo of Fort Ticonderoga showing Mount Independence and Sugar Hill in the distance, 1935.

threat of an imminent bombardment was enough to make the fort's American garrison evacuate under darkness that night, leaving it to the British.

Having used his engineering vision and ingenuity, Twiss was later captured alongside several thousand other men during the Battle of Saratoga. Because of prevailing conditions in the surrender 'convention' document, most of these prisoners of war were to remain in North America until the end of the war in 1783. Dover's Western Heights were started during the American War of Independence following British defeat at Saratoga in 1777, where William Twiss was taken prisoner. He must have felt like he had come full circle when twenty something years later he was in Dover finishing them.

Sparked by a feared French invasion, the alterations that William Twiss carried out to Dover Castle and Western Heights during the late eighteenth and early nineteenth

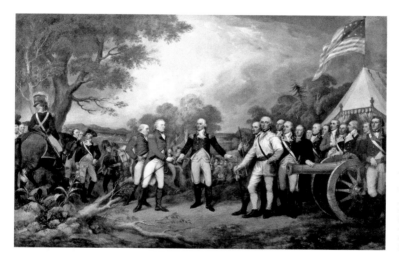

The surrender of General Burgoyne painted in oil on canvas, 1821, by John Trumbull (1756–1843).

Washington Quarter, Saratoga National Historical Park, New York, 2015.

centuries were not the end of the story for these mighty fortresses. Following British victory at the Battle of Waterloo in June 1815, France and Europe was rid of the menace of Napoleon Bonaparte and as a consequence defence spending was halted. The Western Heights defences were left unfinished, but by the 1850s the British government was getting anxious about several factors, including advances in steam ship design, rifled artillery and yet another Napoleon at large in France.

To consider these one by one: firstly, advances in the design of steam propelled warships could potentially have made the Royal Navy's sailing fleet obsolete and this (with the adoption of armour plating fixed to the sides of these ships) could have made a formidable fighting fleet for whichever country possessed them; secondly, moving away from muzzle-loading smooth-bore cannon to breech loaded rifled artillery for both ships and forts was as significant as the move from muskets to rifles because in general, rifled ordnance had a greater range and was more accurate than earlier types of artillery; thirdly, in 1848 Napoleon III (1808–73)[6] was elected President of France. Because France's presidents could only serve one term of four years at a time, in 1851 Napoleon seized power by *coup d'etat*. Five years after Napoleon's coup the then British Inspector-General of Fortifications, General Sir John Burgoyne (after whom Fort Burgoyne was named[7]), penned a memo entitled, 'Memorandum on Defences for Great Britain' in which he stated that, 'there is but one power by which an invasion can be attempted with great force and with great rapidity and that is France...'

Partly because of these developments a royal commission was appointed in 1859 to 'Consider the Defences of the United Kingdom', and this entailed assessing the defences of arsenals, dockyards and likely invasion points along the coast of Britain. The commission recommended that in the region of £10 million be spent on upgrading Britain's defences, around £7 million of which was to be spent just on building new coast defence forts, Dover 'needing' £335,000 to be spent on it. In due course the overall figure was reduced by some £3.93 million. Of the money to be spent at Dover improving and enlarging the fortifications, Western Heights saw massive amounts of spending, turning Twiss' unfinished Georgian defences into a much more elaborate system.

One of the more obvious changes to Western Heights was the modernisation of the Drop Redoubt fort at the most eastern point of the heights and to the west slightly, the North Centre Detached Bastion. In 1804 a 'tower of communication under the protection of which troops might form' was proposed on the north slope of Western Heights midway between the Citadel to the west and the Redoubt to the east by Captain William Ford RE, and thus the North Centre Detached Bastion was begun. During the 1860s both of these structures were altered by having caponiers added to them. A caponier is 'a protected position running across or projecting into a ditch; usually with embrasures and loopholes to provide flanking fire along the ditch.' Simply put, and in the context of Western Heights, these were brick extensions attached to the corners of the fort that stuck out into the dry ditch that surrounded it. They were pierced with loopholes, or slits for soldiers

6 Charles-Louis, *Napoléon Bonaparte.*
7 The son of General John Burgoyne who surrendered to American forces at Saratoga in 1777 along with William Twiss.

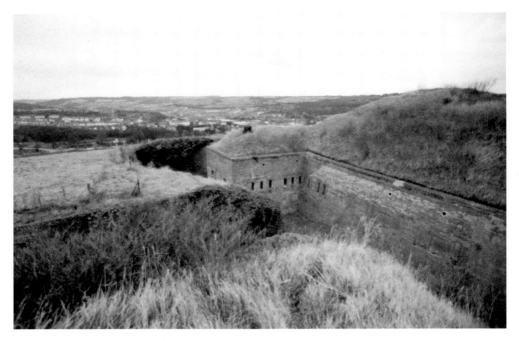

A caponier of the Drop Redoubt, 2000.

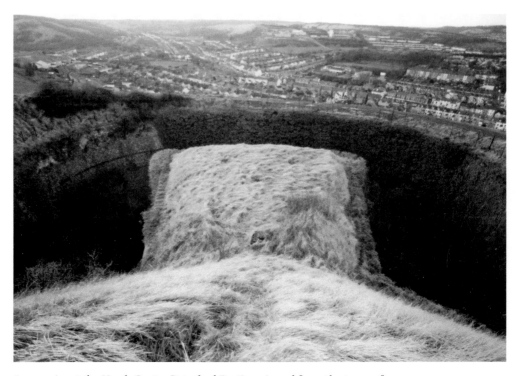

A caponier at the North Centre Detached Bastion viewed from the top surface, 1999.

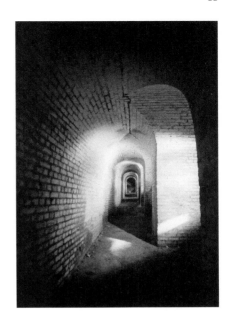

One of the brick-vaulted, loopholed galleries in the North Centre Bastion, 1999.

to fire weapons through. The idea was to provide weapons fire from each side of the caponier along each section of the ditch.

In October 1859 the local newspaper read that 'the works for the enlargement of the Drop Redoubt have been commenced this week. They consist chiefly of "caponiers", from the angles and casemates, to command the old as well as the intended new ditches ... the works are being carried out by Messrs. Stiff and Richardson.' Ten years later the same newspaper reported what had been built at Dover, by now much of the work having been completed. Regarding the North Centre and North Centre Detached Bastions it read, 'In 1866 it was found that the escarp wall of the North-East Bastion was being thrust forward. Remedial measures were at once taken which, at a cost of £1,366, saved the fall, rendering it unnecessary to take it down. The work has since been completed; no further movement of the wall has taken place, and it now appears to be perfectly secure.' The problem the builders experienced with the ditch wall in 1866 was caused by that year's severe winter. There are no further details, but it is quite likely that the mortar being used in the wall's brickwork construction could have frozen prior to it setting, rendering it useless. This wall is around 200 feet long and today there is still evidence of the original loopholed wall and the solid wall built out from it, the two having been tied together by steel rods. By 1869, total (royal commission) expenditure on Western Heights was £291,977, which included £37,577 on the Drop Redoubt and £52,251 on the North Centre Bastion.

The bad winter of 1866/67 that caused the near collapse of a wall at the North Centre Detached Bastion illustrates what a hazardous job it must have been building these immense structures. In August 1860 the local newspaper reported on the death of one Thomas James of Swindon, a workman who had been at the Western Heights when part of a trench actually gave way. Samuel Williams, a fellow worker, gave his testimony at the inquest: 'We were at work, in company with another man, in the north central

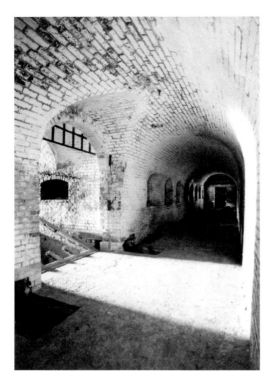

Left: Inside the caponier that connects the North Centre Bastion with the North Centre Detached Bastion, 1999.

Below: One of the gunrooms that was made redundant by having its loopholed wall bricked up, 1999. Note the steel tie rods.

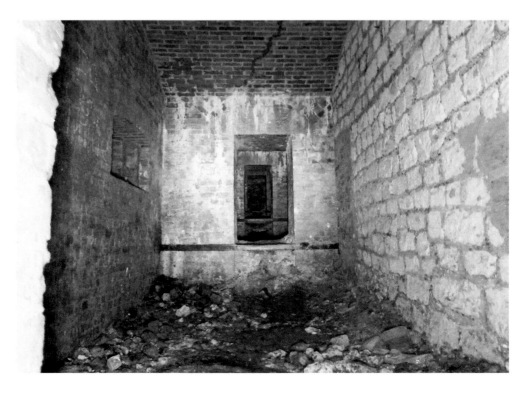

bastion about ten o'clock and were engaged in excavating, when a portion of the earth gave way from the top, I had some difficulty in escaping. On turning round I missed the deceased ... and I soon ascertained that he was buried beneath the earth. Every effort was made to extricate the deceased, but owing to the quantity of earth which had fallen, a quarter of an hour elapsed before we succeeded ... I should think the quantity of earth that fell was not less than forty tons. There was no danger apparent before the fall, and no necessity for shoring, I had worked under the same spot for some days past.' Apparently a leaking water pipe running behind the trench caused the earth to loosen and the trench to collapse. Thomas James was removed to the Dover Hospital where he was attended to by Mr Henry Coleman (of No. 27 Strond Street) and Dr J. B. Gill (of No. 4 Camden Crescent), the house surgeon, suffering from concussion of the brain.

During ongoing excavations at Western Heights the reported evidence points to accidents being caused by the contractor's neglect and his failure to fence off ditches that were partly excavated. For example, another poor soul who died at Western Heights was twenty-nine-year-old Daniel Doherty of the Donegal Militia, who in April 1859 seems to have lost his way in the dark and fallen into a ditch near the Citadel, there being no fencing. Apparently he was on his way back from town where he had been to buy some potatoes for his wife. An examination of Doherty before his death at the Western Heights Military Hospital resulted in the regimental doctor's diagnosis of concussion of the brain. The contractor who was responsible for this part of the works was William Moxon of Parliament Street, London, who lived at East Brook Villas, Dover.

Looking across a ditch of the North Centre Detached Bastion with Dover Castle on the Horizon, 1993.

In December 1860 thirty-four-year-old George Carey of the 47th Regiment died by losing the path back to his garrison at the Citadel from the direction of the Grand Shaft Barracks, whereby he fell around 30 feet into a new ditch that had been cut. (From the description in the newspaper this would make the likely location the ditch next to the Archcliffe Gate.) The inquest was carried out at the Western Heights Military Hospital where the deceased was taken upon being found. During the course of the inquest the jury inspected the site of the accident and expressed astonishment that 'situations of the dangerous description of many which the works embraced should be left with so little protection against accident as appeared to be afforded.' In other words, again there were no fences provided. The prognosis this time was compression of the brain.

Moxon's agent and superintendent of the works at the Heights, Joseph Hiscox, testified at the inquest that the ditch had been in its 'present unprotected state for more than a fortnight, and it is intended to place an iron railing on the top of the coping stone'. The jury recommended that 'greater precaution should be taken by the contractor in fencing dangerous portions of the works bordering the roads' and that lights be placed nearby at night. It is interesting to note that even with the large amounts of spending in Dover at this time, it would seem that the contractor, William Moxon, was going bankrupt. In December 1860 the local newspaper reported a meeting of creditors of Moxon's, who reportedly had debts of £70,000. Nearly a year later much of his machinery and stock in trade was being auctioned. This included steam engines, a travelling crane, drilling machines, carts, winches, ironmongery, anvils, pipes and forges. Also included were 20,000 feet of timber, 20,000 fire bricks, 50 tons of wrought iron bar, 13 tons of lead and much more.

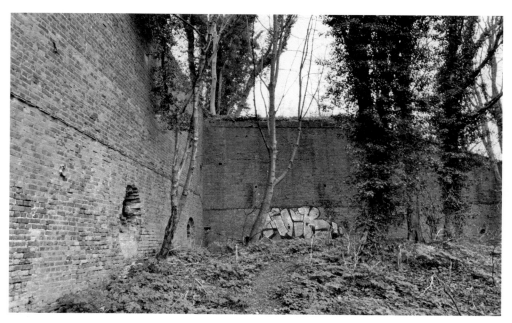

The likely spot where George Carey fell into a ditch. The original depth of the ditch would have been the height of the wall again.

Concussion of the brain seems to have been the *de rigueur* prognosis for the poor wretches injured or killed from falls on Western Heights. This can be seen as evidence of a lack of sufficient diagnosis techniques – after all, this was over 150 years ago. Today the term 'concussion' on its own or 'brain concussion' are more commonly used, rather than concussion of the brain, which seemed to be an all-encompassing term for undefined head trauma. Brain concussion can be defined as 'a brain dysfunction without any macroscopic structural damage, caused by mechanical force'. In other words, a force that causes rapid acceleration or de-acceleration to the head but without any obvious head injury. These days post-traumatic memory loss is a key diagnostic aid in brain concussion, but of the three fatalities outlined here, Thomas James, Daniel Doherty and George Carey, it is not recorded whether they were asked about their accidents. However, upon being discovered James was lucid enough to give his name, Doherty was 'alive and moaning' and Carey was recorded as being 'still sensible and sober'. In addition it can be noted that 'provided the vital centres are not irreparably damaged and complications do not develop, and provided treatment is along correct lines, there should be a gradual and steady improvement in the patient's condition', which in these cases there was not. Unfortunately post mortems are not available for these men. In the much safer twenty-first century these accidents would almost certainly not have occurred, but had they done so, more critically specific diagnoses would certainly be available.

A year or so before poor Daniel Doherty and George Carey were brought into the Western Heights Military Hospital the War Office released a damning report concerning the state of conditions there. It began, 'This building stands on the side of the Heights facing the sea, and has an appearance from a distance of being a much better hospital than it is in reality.' According to the report the twelve wards were too small, providing not enough cubic feet of space per bed; the stairs and passages were confined and narrow; there was no proper ward space for the sick wives and children of soldiers; and there were no proper lavatories. Water was supplied from the Citadel and a rain water tank; apparently there was a well but the water in it was not clean. The few water closets (WC) that were there were drained into a 'most offensive and noxious' cesspit. It went on to say that bedding and other supplies are kept in the basement and are damp, and the windows are old and let in rain. The report also states that the hospital was in a beneficial place and that it could be improved and extended. It also damned the lack of recreation space for recuperating patients and recommended extra space be made by building on to each side of the hospital. The 1881 (revised) plan shows these 'wing' extensions to the main building and the recreation lawn in front, and these are visible on most photographs of the hospital.

The hospital was used well into the twentieth century and all through the First World War. One name that stands out in connection with this hospital, particularly during the First World War, is Matron Louisa Stewart (1861–1943). Stewart was born in Yorktown, a suburb of Camberley, Surrey, in August 1861, and took nursing training at University College Hospital, qualifying in 1889. That year she joined the Army Nursing Service at the Royal Victoria Hospital, Netley, near Southampton. During her career she served in many locations including Gibraltar, South Africa during the Boer War, and Aldershot and Canterbury. In 1902 the Army Nursing Service was replaced by Queen Alexandra's

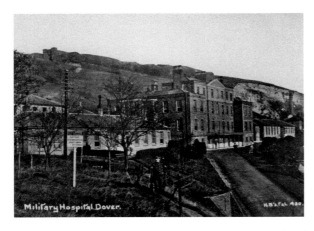

View of the military hospital with the
Archcliffe Gate on the horizon,
c. 1918.

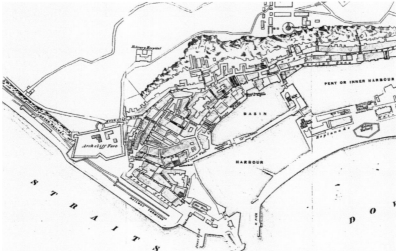

Section of a
1844 map of
Dover showing
the Western
Heights Military
Hospital just
left of centre.
Note the lack of
ward wings and
exercise area
in front.

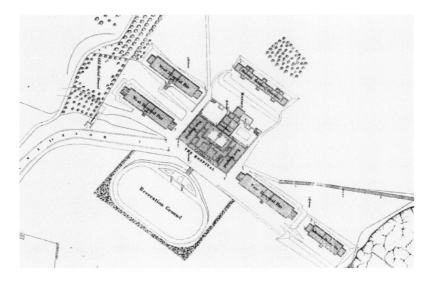

Part of WD map
showing the
military hospital
with extensions
and exercise
lawn, 1881.

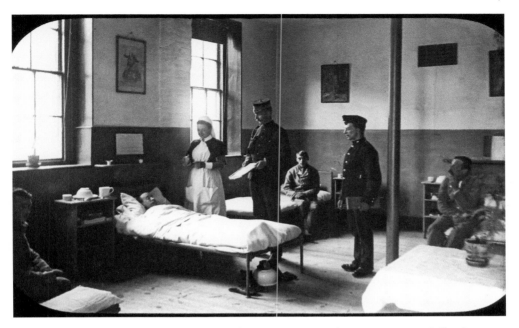

Interior of one of the hospital wards, *c.* 1900. (Dover Museum and Bronze Age Boat Gallery)

Imperial Military Nursing Service (QAIMNS), and positions of authority such as that of matron had to be filled by personnel from a high social status. Matron Stewart, now QAIMNS, was posted to Dover in May 1908 where she served until 1919.

Matron Stewart is mentioned reasonably often in the local newspaper during her tenure at Dover. For example, for her first Christmas there, the newspaper reports that she partook of various festivities, including those held just down the hill at the Royal Army Medical Corps (RAMC) barracks at Archcliffe Fort, apparently both premises being well decorated. Christmas dinner for the 'sufficiently convalescent' consisted of chicken, plum pudding, mince pies, oranges and nuts, and music recitals were given. One of the musical players was thirteen-year-old Jessie Licence, a young rising star in local amateur dramatics. That Christmas Matron Stewart also contributed to a tea party for around fifty of the Dover garrison's children at Our Lady of Pity and St Martin Catholic Church on Snargate Street (this building is now the home of the electrical engineers Smye Rumsby). After a period of illness and exhaustion Matron Stewart retired in 1919 and shortly after received the CBE for her war service. She passed away in July 1943.

By the 1930s the Military Hospital was redundant and became headquarters for the Royal Engineers. The foregoing notwithstanding, information on this hospital is scant, but the fragments that are available when pieced together do create the landscape of a working surgical hospital. Agnes Howard, a member of the Voluntary Aid Detachment (VAD), was stationed at the Western Heights Military Hospital during the First World War. This was a voluntary nursing service established by the Red Cross, and in 1915 the War Office allowed VADs to volunteer within hospitals, which had up to that time been exclusively staffed by the RAMC. Agnes tells us one sad tale from the hospital from that year:

Left: Photo of a replica QAIMNS medal as worn by Matron Stewart, 2019. (Victoria Friedrich)

Below: Painting of Dover Harbour from a window of the Western Heights Royal Military Hospital, *c.* 1918. This has been attributed to Matron Louisa Stewart, but it has the initials 'M.B.' on it. (Kerry Chapman)

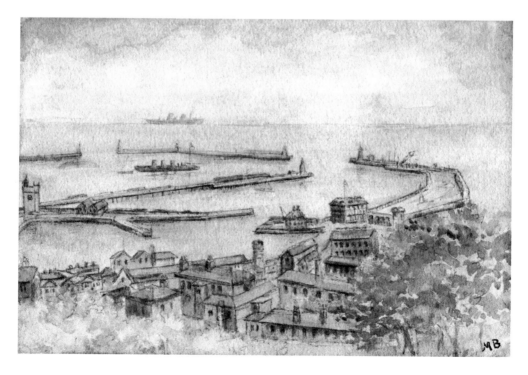

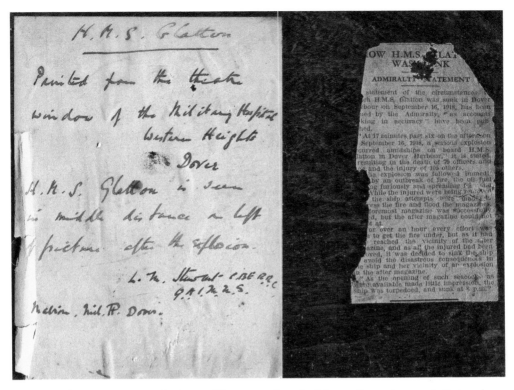

Cutting and note on reverse of painting. The note written by Matron Stewart suggests that perhaps the painting was by a patient who then gave it to her. (Kerry Chapman)

Aerial photo of the site of South Front Barracks, 1999.

there we received the worst of the wounded from the hospital ship – the boys who were suffering from gangrene or perhaps were likely to haemorrhage but couldn't be sent on to other hospitals because they were too ill. I remember one South African boy in particular who had already lost one leg, which had been amputated in France... the surgeon decided that there was no alternative but to remove the other leg. When they were ready for him ... he took hold of my hand and said, "Now for the great adventure!" They brought him back from the theatre but he never regained consciousness after the operation. He just slipped away. Even the surgeon wept.[8]

This hospital used to lie in the dip between the Western Heights proper and Archcliffe, just adjacent to a seventeenth-century plague pit. The hospital was built around 1803 and was contemporary with many of the better-known buildings on the Heights, such as the Drop Redoubt, the Grand Shaft and the Citadel, and this probably accounts for the poor state that it was in by the 1850s. The building wasn't to last though; during the 1960s there was a Dover Corporation plan to reduce unemployment in the town by creating light industrial units on land to be purchased from the War Office. The hospital was one of several buildings to be bought and demolished under this scheme in 1962. As part of this same scheme, which the local newspaper named the 'Archcliffe Plan', a total of 126 acres of land was bought from the War Department. This included 81 acres for the 'Prison Commissioners for the use for a borstal', 14 acres for residential use, 1.25 acres, mostly the system of dry moats for the 'deposit of refuse and waste', and another 94.5 acres as undeveloped open spaces. The area of the Military Hospital was included in a total of 16.5 acres including where Megger now sits, formerly a military prison, an RASC (Royal Army Service Corps) establishment, married quarters, and the site of South Front Barracks, which in 1963 was let to Corrall's as a coal stacking yard for £360 a year. It was part of this scheme that caused the Archcliffe Gate, or south entrance, to be demolished in order to widen the road into the Heights. At Archcliffe and at the site of South Front Barracks businesses have come and gone over the years but on the Western Heights proper there are now none.[9]

8 Macdonald, L., *The Roses of No Man's Land* (Penguin, London, 1993), p. 148–149.
9 By 'Western Heights proper' the author refers to the space between the north and south entrances (or sites of) and the area between the Drop Redoubt and the Citadel.

3. 'Arrived at the Front and Looking Seaward, There Extends Before Us...'

Long before the First World War arrived in 1914 along with its accompanying non-discriminatory consuming of young lives, Matron Louisa Stewart still had to deal with the sad deaths of young men cut down well before their prime. In December 1909, nineteen-year-old Ordinary Seaman James Martin died as the result of an accident aboard his ship, the *Prince of Wales,* while she was moored to the pier of the same name. HMS *Prince of Wales* was a pre-dreadnought battleship of the London class,[10] which was laid down in March 1901 at Chatham, launched a year later and completed in 1904. She displaced 14,150 tons, had a top speed of 18 knots and had a crew of 714. Her armament was four 12 inch guns, twelve 6 inch quick-firing (QF) guns, sixteen 12 pounder QFs and six 3 pounder QFs, along with four 18 inch torpedo tubes. In 1909 she was part of the Atlantic Fleet, the creation of which was the result of a recent change in Admiralty thinking with regards protecting the Channel, the North Sea and the Mediterranean. This redistribution of capital ships was planned to provide naval protection against an emerging German navy and our old adversary, the French. What is interesting to note is that during this period a pre-emptive strike against the German fleet was considered at the highest levels of the Admiralty, and in 1905 the Admiralty view on British security was one of caution against the constantly changing tide of international allies: 'Ententes may vanish – battleships remain the surest pledge this country can give for the continued peace of the world.'

During 1909 various ships of the Atlantic Fleet regularly visited Dover (their base being at Gibraltar), but precise details of exactly which ships came and went are sketchy to say the least. It would appear that the fleet visited Dover three times – once during the spring, in the summer and then in the winter. Four battleships, the *Prince of Wales, Queen, Cornwallis* and *Russell,* arrived at Dover on 5 March and departed 10 April under Vice-Admiral Prince Louis of Battenberg. The battleship *Albemarle* and the armoured cruisers *Good Hope* and *Duke of Edinburgh* arrived at Dover on 1 June.

10 Since the groundbreaking HMS *Dreadnought* was laid down in 1905, warships that immediately preceeded her were known as pre-dreadnought vessels.

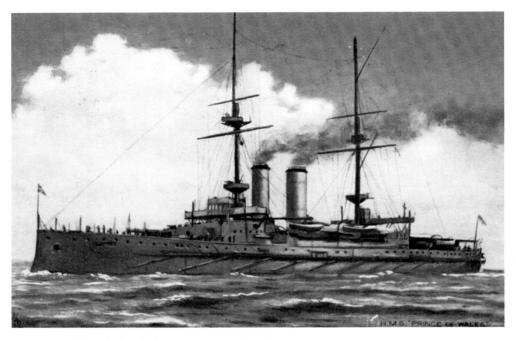

The pre-dreadnought battleship HMS *Prince of Wales, c.* 1909.

During October the local newspaper reported that 'four battleships and six cruisers are expected to arrive, but some of these may leave almost at once for re-fit ... preparations have already been made at Dover for their arrival ... it is probable that some of the ships will moor alongside the Eastern Arm'. During the second week of November it was reported that, 'the *Prince of Wales* and the *Formidable* ... come to Dover. The *Implacable* goes to Sheerness, the *Venerable* will come on to Dover. The remainder, two battleships and six cruisers, are at Gibraltar. These will come to Dover about the first week in December, and they will remain here a good many weeks.' The following week, 'the *Prince of Wales* and the *Formidable* battleships arrived at Dover on Saturday last at two o' clock... the *Prince of Wales* went alongside the Prince of Wales Pier whilst the *Formidable* went to the easternmost buoy in the inner line.' With Christmas just around the corner, it was revealed at the end of November that the *Prince of Wales*, *Formidable, Albemarle, Venus* and *Duke of Edinburgh* will go to their home ports for the holidays, while the *Queen, Venerable, Drake, Doris* and *Argyll* will stay at Dover over the festive season.

The sad accident that occurred early in the morning of 3 December that saw James Martin killed while aboard the *Prince of Wales* was caused by the bad weather and its effect on the ship's moorings while at the Prince of Wales Pier. That morning, the weather was reported to have been squally with a heavy gale, which was 'working' the vessel a little.[11] Adverse weather conditions regularly affected the moorings of ships at the Prince

11 'Working the vessel' – causing it to rock.

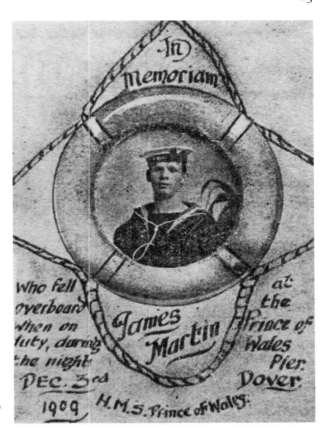

The local newspaper memorial to James Martin, 1909. (*Dover Express*)

of Wales Pier. In 1906 when the breakwater was only partially built heavy westerly tides caused waves to run straight across the pier, making it difficult for liners to run alongside. In September 1909 new, much stronger mooring ropes were fitted to the pier on anticipation of another fleet on its way. It was hoped that the problem would ease when the breakwater was finished, but in October 1910, well after it had been, a Dutch liner, the *Hollandia*, which was moored at the Prince of Wales Pier, could not be moved away from the pier because of a heavy gale. The ship was left there to work away at the pier overnight.

In November 1909, the local newspaper reported that 'The [HMS] *Prince of Wales* has felt it [the weather] more especially as there are no ropes to keep the vessel from rubbing against the landing stage. It became necessary for the *Rambler* to tow its stern at high water in order to prevent the vessel working against the pier. It would seem most necessary that off-moorings should be laid at all the places where the vessels lay alongside to keep them off the piers. Such provision has always been found necessary at Dover in mooring vessels alongside the pier.' 'The strong easterly breezes that have prevailed this week have made the harbour rather uncomfortable.'

According to James Martin's inquest, one of the witnesses, Able Seaman Sidney Sabey, identified the body of Martin at the mortuary, Western Heights Military Hospital. Early

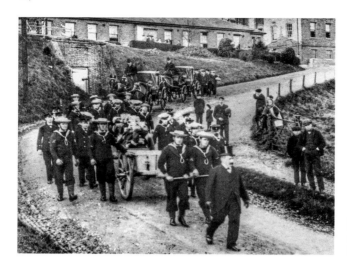

James Martin's funeral cortege at the Western Heights Military Hospital, 1909.

on Friday morning he saw the gangway between the ship and the pier tilt, and James Martin go overboard:

> The gangway tilted to an angle of 25 degrees, through the movement of the ship making it take against a stanchion. He thought the gangway tilted too quickly for Martin to save himself by taking hold of the wire guards. He was only about six yards from Martin when he fell, and he jumped from the deck to the net shelf[12] just in time to see the swirl made in the water as he went down.

Sabey thought that James Martin probably slid off the gangway because of his greasy boots. It transpired that when Martin fell overboard he struck his head on a 'camel',[13] knocking him unconscious and he drowned. The gangways were also known as 'brows', and during September 1909 special longer brows had been made in anticipation of the fleet arriving. These were especially long gangways weighing around 2.5 tons, long enough to reach over the camels from the vessel to the pier, and it was probably one of these that Martin fell from when his ship was being tossed about by the weather.

Martin's funeral procession started at the Western Heights Military Hospital and went to St James's Cemetery via the Market Square and Maison Dieu Road. The cortege included a firing party and a Royal Marine band, and the funeral service was carried out by the ship's chaplain, Revd Moreton. James Martin was buried on 8 December 1909 at plot Oi2. There is no headstone.

Eighteen-hundred years before James Martin's demise at the Prince of Wales Pier, vessels were routinely mooring alongside timber quays at Dover, and perhaps

12 Enemy torpedo trapping nets that extended from each side of the ship when not being used were stowed on the net shelf, a position along each side of the ship's hull.

13 A camel is an inflatable buffer that is wedged between the ship and its mooring to keep it from damaging the pier or jetty that it's attached to.

experiencing similar problems caused by the choppy tide. Remains of these structures have been found well inland and, like some other Roman structures, deep underground.

'Why did t'Romans live underground?' was the question Harry Howe was asked by a northern gentleman while on an archaeological dig with Brian Philp at Reculver in 1962. Harry was at the bottom of a pit, around 7 feet down, scratching away with a trowel at the remains of some part of the Roman fort of Regulbium (Reculver), when this question was asked by the inquisitive tourist. However, is this a silly question coming from the casual inquisitor? Most ground levels tend to get raised up over long durations and today's evidence of Roman building and occupation is, generally speaking, underground. This is because sites and structures get buried by deposits of sand, dust and soil that get redistributed by the wind and rain. Additionally, urban centres tend to be built in layers. For example, a Tudor building might be built on the site of an ancient one, then if that falls down something will get built over its remains and so on. An example of where this effect can be seen is at the remains of the so-called Knights Templar chapel on Western Heights where the low walls are several metres below modern ground level. Where sites have been in constant use this process of sedimentation can get arrested by the effects of cleaning, maintenance and footfall, for example. This partly explains why the ground level around St Edmund's Chapel, for example, has hardly changed. The space around the Knights Templar chapel fell out of use but that around St Edmund's did not.

Evidence for Dover's Roman harbour was first seen in 1855, some 24 feet down in a building site where the new St James's Shopping Centre was built 163 years later. At the time a gasholder was being built on the spot, and Mr William Elsted of Snargate Street sent

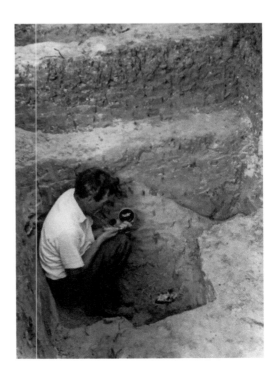

Harry Howe digging the Roman fort at Reculver (Regulbium) with Brian Philp, c. 1962.

a report of his observations to the *Archaeological Journal*, along with a sketch of what he had seen. He described a framework of foot-square oak beams, with right angle pieces between the beams 2 feet apart, all dovetailed together. The framework that seems to have been destroyed in the gasholder building process was seen to be in perfect condition and sitting on a bed of peat, and this is probably what preserved it. The *Archaeological Journal* described the exact make-up of the framework, and how it would have been rammed full with 'shingle and hard ballast', apparently to form a pier or causeway. Apparently it was situated on a north-east, south-west axis, 'the ends disappearing under neighbouring properties.' At the time it also reported that nothing like it had been seen to date, but 150 years later jetties and quays of similar construction have been found in London.

When excavations were made for the building of the bus garage at St James's in 1924, no timber was found, but samples of the soil were taken 18 feet down. The samples were taken at the approximate east and west boundaries of the site, roughly between Phoenix Passage and Fector's Place and 30 feet south of Dolphin Lane. In the holes close to Dolphin Lane deposits were found containing the type of mud that would be found at the bottom of a river. At sea level (in 1924) the holes were sunk into beds of sand, which contained flint. A similar result, but of a rather unorthodox experiment carried out in 1784 has been told by William Batcheller in one of his guides to Dover. Lieutenant Sir Thomas Hyde Page, a Royal Engineer who was partly responsible for designing the fortifications on Western Heights, had a hole bored somewhere 'under the Castle Hill', at a point where

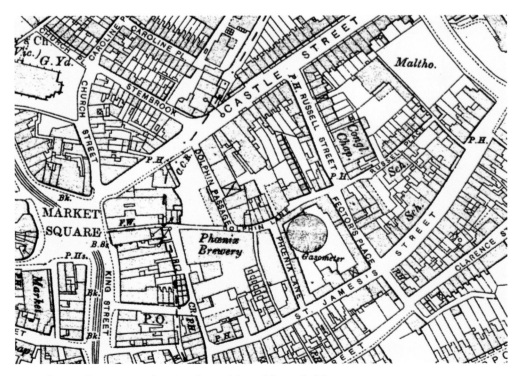

An Ordnance Survey map showing the position of the gasholder, 1907.

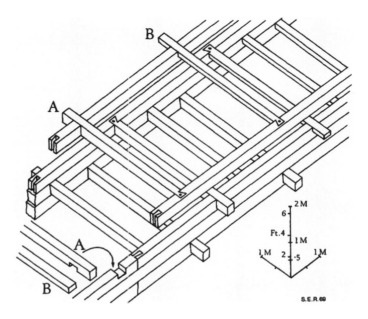

Sketch of the Roman quay, 1969. (Rigold, *The Roman Haven of Dover*)

the River Dour was thought to run in the first century AD. According to Batcheller, Hyde Page was able to prove that the (first century) water level was 30 feet lower than the contemporary (1843) high water level, and around 100 yards from the 1843 shore line. He also relates how a well was sunk in Dolphin Lane in 1826, and the sediment found 21 feet down was a layer of mud with the type of rotted material that one would expect to see at the bottom of a river.

In his *Vestiges of Dover* of 1893, Revd Canon Puckle, vicar of St Mary's and an enthusiastic antiquarian, wrote a synopsis of archaeological findings in relation to the 1855 discovery. The Roman harbour, he mused, filled a small space roughly contained within an imaginary boundary of St James's Street, Russell Street, the east end of Dolphin Lane and Phoenix Lane. He mentions the uncovering of archaeological remains with the building of the gasholder that included 'timbered quays, groins, warping gear, hawser rings, and other remains', although Elsted does not mention these 'other remains'.

During construction of the A20 road extension in 1993 a timber structure of Roman construction was found at the junction of Bench Street and Townwall Street. The report suggests that this was part of a large timber box frame from a Roman harbour wall. The find comprised two beams with horizontal cross-beams aligned in an east–west orientation and were found just 2.5 feet below the surface, evidently with the upper part of the structure having probably been eroded away by the sea. Although this latest Roman harbour find was around 590 feet away from Elsted's 1855 structure to the south-west, the two were on about the same axis.

In summary, these pieces of evidence show that not only was Dover's Roman seafront much further inland than it is today, but that the Romans created a harbour here, no doubt for cross-channel trade and the movement of troops. Brian Philp (of the Roman Painted House) asserts that there is 'clear evidence that the tidal estuary was adapted as

Part of a Roman quay found while the A20 extension was being built, 1993. (Keith Parfitt, Canterbury Archaeological Trust)

Boring for core samples at St James's, hoping to find traces of the Roman quay, 1993. (Keith Parfitt, Canterbury Archaeological Trust)

a major harbour during the Roman period and it must be that this development took place no later than the first half of the second century.' The various bits of timber quay or breakwater that have been found over the last 150 odd years that 'lay across the axis of the estuary must surely represent the outer limit of the Roman harbour'.

Around 1,400 years after the development of Brian Philp's second-century harbour, and further south-west, a Tudor pier or jetty was being built just below the promontory on which Archcliffe Fort now sits. The harbour, known simply as 'Paradise', was probably started around 1500 and occupied the space between the fort and the site of the Limekiln roundabout. Known to depict part of that early harbour is a painting at Hampton Court, artist unknown, entitled *The Embarkation*, and shows Henry VIII (1491–1547) leaving Dover Paradise on 31 May 1520 en route to meet Francis I, King of France, at the Field of the Cloth of Gold, the subject of another painting. *The Embarkation* shows a fleet of ships leaving Paradise, with two large gun towers on a jetty in the foreground and Dover Castle in the background and off to the left. It is an impressive painting, but there

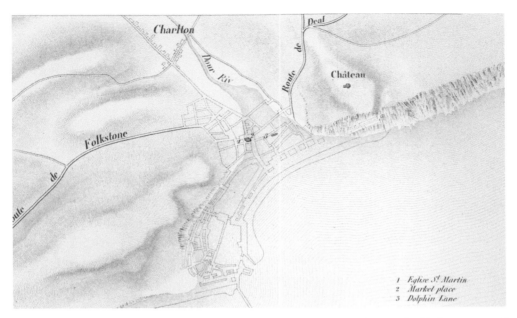

1866 map showing Dover's coastline in Roman times. The red line indicates the likely position of the Roman quay. (*Napoléon III, Histoire de Jules César, Tome Deuxième, Guerre des Gaules, Rome, Empire Français*, 1966)

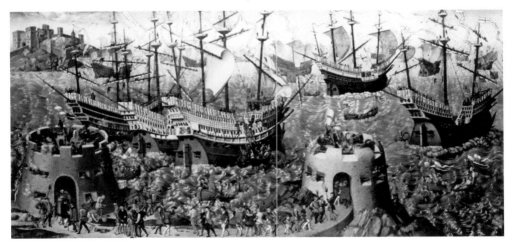

The Embarkation, a mid-sixteenth-century painting of Dover Paradise harbour, *c*. 1540. (Royal Collection Trust/© Her Majesty Queen Elizabeth II, 2019)

are inaccuracies within it which make it unreliable as a dating source for the towers, even though it shows an event that we know happened in 1520. For example, a scan of academic sources cites the style of clothing that the people on the jetty are wearing to a date range of between 1537 and 1553.

The site of the early
Tudor harbour Paradise
from Archcliffe Fort.

The jetty and towers in the painting are known to have existed and formed an outer harbour arm to Paradise. Their main purpose was to stop the build-up of sand and pebbles that continually blocked the entrance, a problem that was to continue unabated throughout Dover's various harbour developments until the modern harbour was enclosed in the early twentieth century. There is not a wealth of sources that help in correctly dating these structures at Paradise, but a scan of the nineteenth-century literature, particularly the plethora of guides and perambulations that were printed, do provide some good clues. For example, William Batcheller in his 1828 *New History of Dover* tells us that; 'John Clerk, who was master of the Maison Dieu[14], being provided with funds by Henry the Seventh, constructed a wall of chalk and earth ... and ... built a round tower ... another round tower was also built, in the intermediate space, in Round Tower-Street.' In the area once known as the Pier District there was a Round Tower Street and a Round Tower Lane, so this makes sense.

Revd Statham in his 1899 *History of the Castle, Town and Port of Dover* noted that, 'About the year 1530 Clerk's Embankment was partially destroyed and the harbour in danger of being rendered entirely useless.' According to Statham, John Thompson (rector of St James's Church) petitioned Cromwell, the king's minister, to have Clerk's jetty repaired, and work was started. Statham continues: 'a pier some 130 rods in length was constructed, composed of strong wooden piles driven into the rock in parallel rows, bolted and banded together, the intervening space being filled with blocks of sandstone and chalk. This pier enclosed what was known as Paradise Pent.'

These sources and many like them may not be entirely accurate but they do give a good idea of where to start looking for clues to the possible location of the towers. For example, John Clerk is not mentioned in any primary records until 1518, so he could not, as Batcheller has it, have been provided with funds by Henry VII (1457–1509). Official

14 The Maison Dieu was founded in 1203 and offered hospitality to pilgrims.

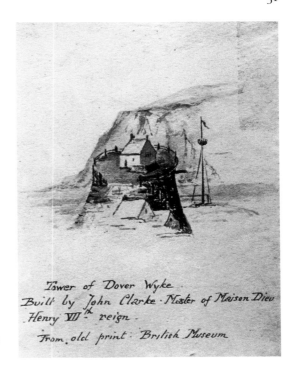

Tower of Dover Wyke, built by John Clarke, Master of Maison Dieu, Henry VIII's reign. From old print: British Museum

Tower of Dover Wyke, the remains of one of Clerk's towers, probably being used as a pilot's tower, c. 1540.

records do indicate that there was a stone-built structure in place at Paradise harbour by 1510 and that repairs were carried out to it between 1513 and 1515. In 1521 John Clerk is recorded as 'Warden of the Wyke',[15] and was paid for four years' work on the harbour. If these two building periods are an indication of two distinct building schemes, this would correlate with two towers being of differing styles, the earlier tower being the one to the left in *The Embarkation*. Until recently the exact positions of the towers relative to a modern map of Dover remained elusive, and this is partly due to the inaccuracy of the painting and the lack of any remaining structures from that period in the right area to give context. However, it has been possible to locate the two towers' relative positions, one tower from a clue that William Batcheller gives us and the other tower by a piece in the local newspaper from 1866.

In discussing the 'left' tower in *The Embarkation*, Batcheller tells us that, 'the foundations of this tower remain in Round Tower-street, under three houses built by Mr Church, in 1798.' Jatt Church (?–1808) did indeed own three houses in either Round Tower Street or Round Tower Lane (the names of the two streets seem to vary from map to map). This makes sense because it was around this time that Batcheller also tells us that the now 'little' Paradise harbour 'became a waste, useless, and unhealthy swamp, covered with reeds and bulrushes; and continued in this state for more than a century. The ground was occasionally raised, and, as it became firm, houses were built on it; but the progress was by no means rapid, prior to the year 1798.' So Jatt Church's houses were built on

15 Warden of the Wyke was an official position associated with the harbour.

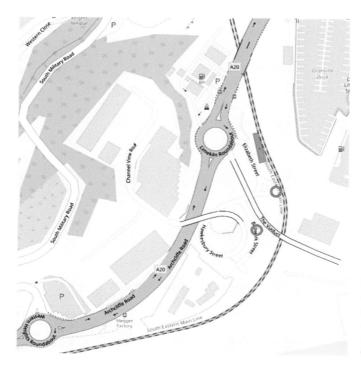

The probable centre points of Clerk's towers shown on a modern map and marked by red circles, c. 2018. (OpenStreetMap Contributors)

land reclaimed from the Paradise harbour. As far as the 'right' tower is concerned, the local newspaper in 1866 reported that 'by the demolition of the buildings in Round Tower Street, a portion of King Henry the Eight's Tower has been disinterred'. At this time many properties were being demolished to make way for new buildings associated with the Dover–Calais steamer service. These two pieces of information have enabled this author to accurately locate *The Embarkation* towers on a modern map of Dover.

The first stage in creating an enclosed harbour in Dover was begun in 1847 with the construction of the Admiralty Pier. This was essentially a huge breakwater built to withstand the immense pressure of the surging water. It was built out from a point known as Cheeseman's Head, a name that crops up regularly when researching the old harbour on the west side of Dover. The initial phase of the Admiralty Pier was completed by 1871, and at this time it terminated at the point where the large artillery turret (the Dover Turret) is situated. At this point the pier was 2,100 feet long, an average of 91 feet being completed annually. As the pier grew and a sufficient length of construction had been accomplished, vessels of the cross-channel mail service began using it to berth, and this started as early as 1851 when presumably no more than around 360 feet could have been built. The obvious curvature of the pier was designed in order to give protection to berthing vessels from the south-westerly winds and from strong channel currents, yet it was not long before it was realised that the structure was also protecting the harbour mouth from building up with beach or shingle, a problem that went back centuries, as discussed earlier.

The rotating gun turret at the end of the Admiralty Pier, known as 'the Dover Turret', started life in a Defence Committee meeting in 1870, where 'the design submitted to

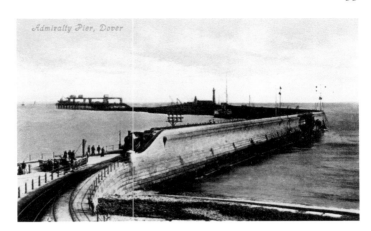

Building the Admiralty
Pier extension, 1905.

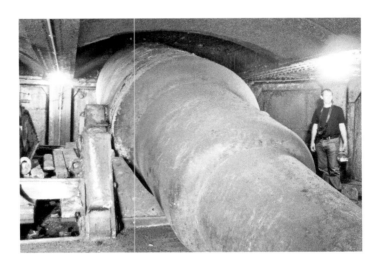

One of the 81-ton
guns inside the Dover
Turret, 2006.

them for the construction of a turret for two of the most powerful guns at the extremity
of the Pier' was approved. On 12 May 1882 the second gun was mounted and in July
the following year they were test fired. The guns in question were 16 inch RMLs, each
weighing 81 tons.[16] Two projectiles for these guns now sit outside the officers' mess at
Dover Castle. For another sixteen plus years the turret marked the end of the Admiralty
Pier, but as plans were being made to extend the pier worries were being voiced that the
block work on which the turret sat was 'far too weak' for its heavy guns. Royal Engineers
were on the scene carrying out various tests to the foundations with a view to extending
the pier some 40 feet to protect it from the fierce current of the water. Along with a plan
to actually dismantle the turret received in 1898, the pier was successfully extended and,
thankfully, the turret remained.

16 RML – having rifled barrels and being loaded from the muzzle end, that is, the end the shell exits once the
 gun is fired.

Construction work to extend the pier another 2,000 feet began the same year as part of a grander scheme to enclose the whole of Dover Bay. This scheme included plans to build an Eastern Arm out from the cliff under Langdon Hole some 3,320 feet, and to build a breakwater 4,300 feet long to close the harbour. By November 1898 it was reported that 'the cement shed is nearly finished, whilst close by a couple of concrete mixers have been mounted. Platforms for running the trolley to fill the block moulds are also being completed.' This may sound like trivial stuff, but 'the first of the great travelling crane [*sic*] is also being erected. It is a very heavy crane, as it has to deal with blocks weighing close on fifty tons.' By December 1898, the *Times* reported that, 'the contractors, Messrs S. Pearson and Sons, have [*sic*] now ready and are waiting for a favourable tide to drive at the end of Admiralty Pier the piles necessary to form the staging from which the blocks will be lowered.' By 1909 the enclosed harbour as envisioned in the previous century had come to fruition, and it was officially opened by the Prince of Wales on 15 October 1909, where he laid the foundation stone of the Eastern Arm amid a ceremony of pomp.

By 1946, the Belgian government had been running a steamer service between Ostend and Dover for a century. At first it only carried mail and packets one way, letting the Admiralty transport mail across the Channel to Belgium, then in 1854 that responsibility transferred to a local contractor, Messrs Jenkins and Churchward, trading as the English, French and Belgian Royal Mail Company. By 1862 the Belgian government ran their mail service in both directions, and the steamers that carried the Belgian state mail unloaded both passengers and packets at the new Admiralty Pier. The Belgian State Railway office

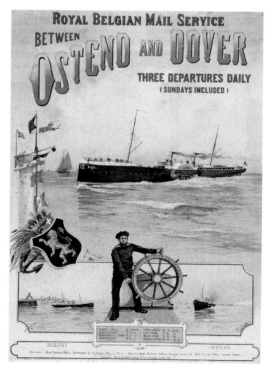

Advert for the Ostend and Dover boat service, 1886.

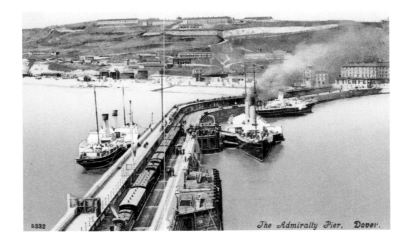

Aerial view of Admiralty Pier with moored steamers, c. 1900.

was situated at No. 18 Strond Street, and the day to day loading and unloading of these packet boats was left to a little known group of men, essentially porters, bearing the impressive collective title the 'Belgian Shore Force'.

Little is known about this band of no-doubt hardworking, salt spray-hardened men. The fragments that can be collected and distilled include Mr David Samuelson of Beach Street, foreman of the Shore Force in 1896, who received a commemorative star from the then lady mayoress on behalf of the Belgian government for completing twenty-five years' service. Eight years later in July 1904 the local newspaper reported on two men who had saved the life of a pair of boys who had fallen in the Granville Dock on 16 April. F. W. Prescott, JP, representing the Royal Humane Society, asked the mayor at a regular town council meeting to present a pair of society certificates to the two men 'for gallantry in saving life'. The local newspaper reported that 'on the 16th April last two children, aged six and eight years respectively, were playing on some steps at the corner of the dock when they fell into the water ... Mr Browning, of Whitstable ... jumped into the water ... A member of the Belgian Shore Force at Dover, named Charles Howe (1863–1914), was passing along the quay at the time, and seeing what had happened he also sprang into the water, and by their promptness both the boys were happily saved. In presenting the certificates to Browning and Howe, Sir William Crundall said it afforded him the greatest possible pleasure.' Charles Howe was this author's great-grandfather.

One fragment of an odious character as reported by the local newspaper in 1909 tells of a dispute between the men and their employer, the Belgian government. It would seem that the Shore Force was being made to work a forty-eight-hour shift at the Admiralty Pier, living on a day-to-day basis in a cabin that was just nearly 11 feet long by 8 feet wide and 9 feet high, with seven men 'living' there at any one time. The Belgian Shore Force petitioned the Belgian government: 'We the undersigned, being members of the boats crew ... in connection with the Belgian steam boats ... lay before you the hours and conditions of our services for your consideration.' This petition, which was printed in the newspaper in full and dated 27 February 1909, explained that the men now had to work forty-eight hours 'on' with only twenty-four hours 'off', starting at 8 a.m. and finishing at 8 a.m. on

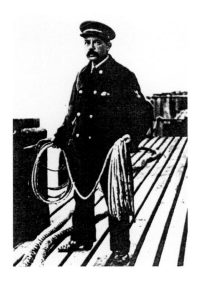

Charles Nestor Howe of the Belgian Shore Force, *c.* 1914.

the second day, and during this time had to be in constant attendance at the Admiralty Pier. They iterated the cramped living conditions, in particular that the 'air space is further lessened by the room containing four lockers, six bunks, gas stove etc. The two upper bunks are so near the gas that it is found impossible to use them at night. There is also no lavatory accommodation where we can wash during the forty-eight hours duty.'

According to the following week's 'paper the Belgian government would not repent and threatened to lay the men off and install their own Belgian crew to deal with the steamer traffic. There is no printed resolution to this dispute other than to say that a Belgian government official arrived in Dover to sort it out. From a newspaper report some four years later though, it is evident that the situation had improved. At an enquiry regarding housing in the Pier District, Mr Dolbear of No. 54 Bulwark Street, who worked in the Belgian Shore Force, testified that the men he worked with, ninety-one in number, found it difficult to travel to their shift at the Admiralty Pier unless they lived locally to it. Apparently, they now worked three shifts or 'watches': an early morning watch, 3 a.m. to 3 p.m., then the next watch would begin at 10 a.m. and last until 11 p.m., then the night watch started at 2:30 p.m. and went on until 5 a.m. the next day. Quite when this new shift pattern was introduced it is hard to say, but perhaps the men's petition of 1909 did the trick.

Charles Howe, who in 1904 was commended for helping to save the lives of two boys that had fallen in the Granville Dock, died a decade later. He was not quite fifty-two years old, the age of his great-grandson now! He was buried at Charlton Cemetery in November 1914, and a great show of people turned out. The mourners included members of the families Howe, Hayward, Tomlin, Terry; his old shipmate, Tom Merton, Uncle Jack and Alma; Mrs Ayers and Mrs English (junior) from Victoria Street; Mrs English (senior) from Union Road; and the Crushes, the Ballards and his future daughter-in-law Nellie (Ellen) Tomlin (my grandmother). These are some Dover surnames of old, some of whom I am related to. The floral tributes included, 'in loving memory of an old shipmate, from the members of the Royal Belgian Shore Force'.

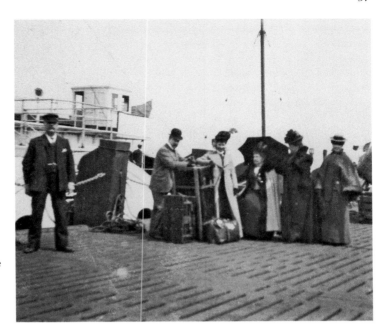

The Belgian Shore Force unloading passengers and luggage from the Ostend boat at Admiralty Pier, *c.* 1900.

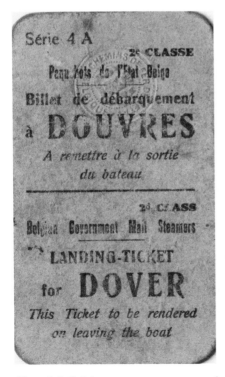

Above left: Belgian government steamer landing ticket, *c.* 1900.

Above right: A landing stage on the west side of the Admiralty Pier, 2018.

4. 'At the End of the Promenade Pier ... is a Pavilion Used for Dancing, Entertainments, etc.'

In July 1864 the local newspaper reported that the promenading area along the Admiralty Pier was 'very attractive to townsmen and visitors alike' and that 'when finished it will be without exception the finest marine promenade in the kingdom.' This promenading space was 11 feet and 8 inches above the railway lines and extended some 500 feet. Five years later a plan emerged that involved enlarging the harbour and in doing so improve communications with the Continent. This involved building a bespoke promenading pier further east somewhere between Admiralty Pier and Castle Jetty. Within the town council there was a 'for' camp, and one 'against' the building of such a structure. The 'for' camp, which included former mayor of Dover, Joseph George Churchward, argued that such a pier would constitute an improvement to the town as a 'watering place'. The 'against' camp, including Alderman Knocker, the then current mayor, argued that a pier built on the esplanade would 'destroy the bathing', which he considered to be one of the greatest attractions of the town.

The Dover Promenade Pier Company intended to raise capital of £25,000 to build the 600-feet pier plus landing stage for pleasure steamers west of the Royal Baths (the site of today's Premier Inn hotel). However, the Dover Harbour Board (DHB) and the Dover Corporation still objected to the scheme on the grounds that a pier would obstruct access to the esplanade, interfere with the privacy of bathers and be an obstruction to shipping and general navigation. The DHB also objected to the imposition of a pier because they owned the foreshore (that is the seafront esplanade that a new pier would butt up to) from Admiralty Pier east to the stone boundary groyne opposite Guilford Battery (the now demolished old army recruitment building under the castle cliff).

The Board of Trade objected to the scheme simply because a new pier could be a potential hazard to navigation. The Corporation also continued to object on the grounds that such piers were dangerous. Councillor Irons referred to a recent accident at Deal where eight lives had been lost following an accident where two luggers were launched in an effort to assist another vessel in trouble on the Goodwin Sands. On launching, one of the luggers crashed into Deal Pier and started taking on water, the poor crew succumbing to the waves.[17] In 1871 the Dover Corporation sent the Board of Trade a letter documenting fourteen points of objection to a pier scheme. Objection number five was on the grounds

17 A lugger is a small fishing boat.

that 'nuisance may be engendered, prejudicial to the health of the inhabitants and garrison.' This rather coy sentence was a reference to the fact that at the spot where the pier was to be built was a sewage outlet from the castle. The objection stated that the pier will be next to 'the outlet sewer belonging to the War Department, which sewer is brought from the Castle under Guilford Battery ... and discharges the sewage from the garrison of the Castle into the sea there.' It went on to admit that, 'Annoyances are occasionally experienced from this sewer, and it is only by great care and attention being paid to the flushing by the military authorities that great nuisances are avoided.'

Fast-forwarding to 1888, the local newspaper asked the question, 'Is there to be any practical outcome of the letter writing about a promenade pier? So far the evidence has been to prove that such a pier would be an attraction...' The Dover Promenade Pier and Pavilion Company Ltd was formed in 1889 under the Dover Promenade Pier Provisional Order and was built as a tourist attraction and money-making venture. The founding shareholders were all Dover businessmen and the board comprised:

William John Adcock	Contractor	Dover
William Henry Crundall	Timber merchant	River
Sir Richard Dickenson	Provision Merchant	Dover
Alfred Leney	Brewer	Dover
Edward Lukey	Wine Merchant	Castle Hill
George Crowhurst Rubie	Wholesale Grocer	Dover
James Stillwell	Solicitor	Dover
Herbert Stiff	Contractor	No. 23 Waterloo Crescent
Henry William Thorpe	Army Contractor	No. 95 Snargate Street

The design of the pier itself was the result of a competition, the prize of which was £100 that was won by a Mr J. J. Webster of Liverpool, who had some experience of designing seaside piers. The pier was built slightly further west of the original position, well away from the castle's sewage outlet, and opposite the Burlington House Hotel (where the new Travelodge is). Following approval of the plans by Dover Harbour Board on 11 July 1891 and the Dover Town Council surveyor, building work finally started in December of that year. On 11 December 1891 the local newspaper reported that, 'Considerable progress has been made in getting in the concrete foundations for the shore end of the Dover Promenade Pier.' The following week the newspaper stated that, 'Considerable progress has been made with the Promenade Pier and three of the iron pilings have been sunk.'

The pier was finished in 1893 and it was opened by Lady Dickson on 22 May that year. It was approximately 940 feet long, including a landing stage on its far end, and the promenade was around 17 feet above high water mark. Over the ensuing years the pier company was not a financial success, and to make matters worse, in November 1895 100 feet of the pier was taken away by severe storms. The damage was only part paid for by the insurance company, the pier company having to find £500 to pay the repairers Messrs Murdock & Cameron of Glasgow. The pier was to receive a pavilion, which opened on 15 July 1901, but even before this impressive structure was built concerts and recitals were to be heard on the pier.

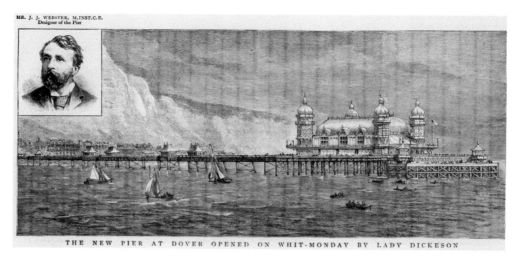

MR. J. J. WEBSTER, M.INST.C.E.
Designer of the Pier

THE NEW PIER AT DOVER OPENED ON WHIT-MONDAY BY LADY DICKESON

An artist's impression of the Promenade Pier with the design by J. J. Webster inset, 1893. (The Graphic)

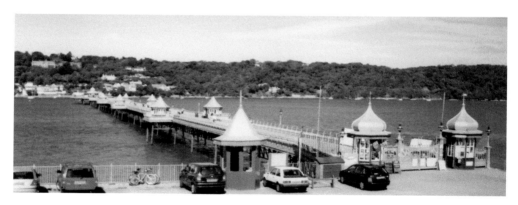

Bangor Pier, also designed by J. J. Webster, 2003. Note the similarities.

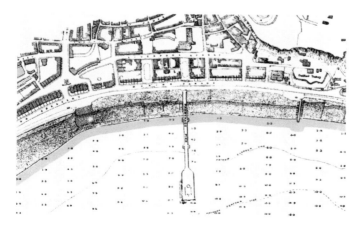

Section of a chart of Dover showing the seafront and Promenade Pier, 1896.

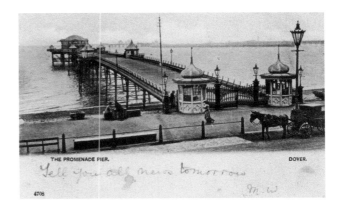

THE PROMENADE PIER. DOVER.

Dover Promenade Pier, 1904.

During June 1900 the local newspaper reported: 'The Promenade Pier attracted a good many people this Whitsuntide by the band performances in the evening. On Sunday 1,300 passed through the turnstile and on Monday 800. The Band of the 4th Battalion, Royal Dublin Fusiliers played on both occasions.' 'The total number passing through the turnstiles of the Promenade Pier for the week ending June 17th was 3,131. A military band will give a concert on the pier on Sunday evening next, commencing at 8 o'clock. There will be several steamer trips from the pier next week, and the saloon steamer, *Alexandria*, is advertised to run a special trip on Dover Trades Holiday, July 11 to Hastings, St Leonards, Eastbourne and Brighton and back to Dover.'

The new pavilion opened as planned in 1901 with a celebratory concert given in its new 900-seat concert hall. In further celebration there were concerts every morning, afternoon and evening throughout the summer. The pavilion was 83 feet long and 50 feet wide and was built with a miscellany of rooms. There was a stage measuring 38 feet by 29.5 feet, a dining room, bar, kitchen, reading room/stage master's office, green room, four dressing rooms and a ladies' and a gentlemen's waiting room.

However, neither a varied concert programme or a busy timetable of pleasure steamers could save the business. Although numbers through the turnstiles were at first impressive, the Promenade Pier was one of three local seaside attractions where Dovorians could spend their free time, and they were all very close to each other and offered very similar entertainments. The Granville Gardens just along the esplanade had a regular music programme, and in 1910 the Dover & District Rink Ltd company opened a skating rink, something that the pier also offered. The total cost of building the pier and pavilion was nearly £27,000, and with too much competition the pier company was forced to voluntarily liquidate in May 1913. The company had been trying to sell the pier since 1909 and after many aborted attempts and much haggling, the structure was sold to the Admiralty in 1912 for £8,000. The pier was renamed the Naval Pier and some entertainments still carried on, this time with permission from the Admiralty's representative. Members of the Discharged Soldiers and Sailors Federation held dances there, crews from departing warships had 'sing songs' there, and for the public, whist drives, trips on the lifeboats, fishing, and the more familiar form of entertainment, the Dover Regatta.

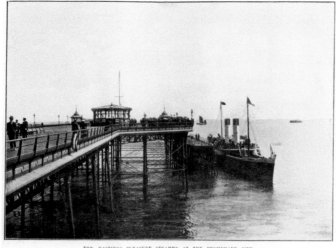

THE HASTINGS PLEASURE STEAMER AT THE PROMENADE PIER.

The Promenade Pier with a paddle steamer at the landing stage prior to the pavilion being built, *c.* 1900. (*Views of Dover*, W. Parsons)

One of the original pier gates now located at a farm near Maidstone, 2002.

By August 1921 the consensus was that 'one eyesore on the Sea Front is the Naval Pier. It is such a state that it cannot be used with safety ... there should be strong representations made to the Admiralty to remove it.' Such representations must have been successful because it was finally demolished in July 1927. Its ironwork, guttering, lead, timber planking and metalwork was sold off at two auctions that month, and the once grand Promenade Pier was no more.

Of the many artistes that performed on the Promenade Pier, one was a local girl, Esme Atherden (1878–1964), real name Emma Elizabeth Atherden. In 1896 she lived at

"THE MAGIC FLUTE."

Opera in Two Acts, by Mozart,
Performed by Students of the Royal College of Music,
at the Lyceum Theatre, Dec 12th.

The Queen of Night	E. DELIA MASON
Pamina	CICELY GLEESON-WHITE
Papagena	ESME ATHERDEN
Ladies of the Queen of Night	ESME ATHERDEN
	MABEL BOND
	LALLA PARRY
Genii of the Temple	PHŒBE PARSONS
	MAUD TURNER
	GRACE WINTER
Tamino	GWILYM EVANS
Monostatos	WALTER HYDE
Sarastro	EDWARD GORE
Papageno	RALPH COURTIER-DUTTON
The Speaker of the Temple	SAMUEL EPSTEIN
Priests	HAROLD WILDE
	NORMAN RIDLEY
Armed Men	E. DUMAINE
	WILLIAM BASSETT

Advert for 'The Magic Flute' featuring Esme Atherden and her future husband, Walter Hyde, 1899. (The Era)

home with her family at No. 21 Hawkesbury Street in the Pier District, and like many other households in that area it was a navy house; her father George was a stoker on cross-channel packet steamers. The same year following an audition in Canterbury, Esme, now eighteen, was accepted into the Royal College of Music (RCM), where she trained until March 1901. Esme was a soprano, and while at the RCM she performed in Wagner's 'Die Fliegende Holländer' in December 1898, Mozart's 'Die Zauberflote' the following year,[18] and in November 1900 she played Euryanthe in Weber's opera of the same name. Esme was already singing to audiences in Dover before leaving the RCM, and when the pavilion on the Promenade Pier was opened in July 1901, she was part of the musical line-up. She sang 'Husheen', 'Who'll Buy My Lavender' and 'Down the Vale'. In all, she appeared over a dozen times in Dover between 1900 and 1907, singing either on the Promenade Pier or at the Town Hall.

Like all artistes destined for a life on the road, she performed in other towns and cities. In 1899 while she was still training, *Jackson's Oxford Journal* reported that Esme had 'a sweet and well trained voice, which is heard at its best in cheerful, sprightly music.' In 1906 the *Gloucester Citizen* was 'pleased with the opportunity of listening again to her charming singing. Purity of tone, clear enunciation and appropriate expression ... combined in the present instance to produce an excellent rendering of Liszt's dramatic ... legend' (Orpheous).

On 15 November 1905 Esme Atherden sang in the Town Hall along with Marion Pilcher, Walter Hyde and Adolf Fowler, whom she knew from performing at the pier. Esme had met Walter Hyde (1875–1951) while studying at the RCM, and in fact they had become married seven months before this performance. Walter Hyde had started his training at the music department of the Birmingham and Midland Institute in 1895, had spent four years at the

18 'The Flying Dutchman' and 'The Magic Flute'.

RCM and had risen to become a prolific opera star, being well known for his Wagnerian roles. He twice performed at Dover during his early career, both times at the Town Hall, the other performance being in February 1904. He performed and recorded extensively until retiring in 1928, his last performances being at the Leeds Triannual Music Festival that year. During his career he had performed under Sir Thomas Beecham, and had been instrumental in starting the British National Opera Company. During 1906 Walter Hyde made two recording visits to Edison in London and was accompanied by his wife Esme Atherden. While there Esme recorded two songs on phonograph cylinder: 'Annie Laurie', which she had sung in a Town Hall concert that June, and 'Love's Old Sweet Song'.

The Promenade Pier pavilion opening night in July 1901 also included performances from a handful of other artistes. These were Herr R. Muller's Pomeranian Orchestra, and the tenor, Mr Wills Page, who sang three popular songs of the era, 'The Sailors' Grave', 'Other Lips' and the later Walter Widdup favourite, 'Let Me Like a Soldier Fall'. Wills played Dover six times between 1898 and 1904, three times at the Town Hall and three at the Promenade Pier, each time at the pier with Esme Atherden. He was well known as an oratorio singer, but also sang standards, recording ten works in 1899 for the Gramophone Company. By 1903 he had added six more recordings to his repertoire, two numbers of which he had sung at the pier in 1901. (These recordings are particularly interesting because they were recorded on some of the earliest flat disc records by the Gramophone and Typewriter Ltd. The flat disc record was invented by Emile Berliner in 1887 and superseded Edison's wax cylinder record.) At this same performance Mr Astley Weaver provided humorous sketches, and the soprano Clare Addison also sang. Page, Weaver and Addison, like many other light entertainers of the time, toured the country playing at piers and concert halls.

Another artiste who spent his life on the entertainment 'road' was tenor Gwilym Richards (1871–1946). Gwilym sang in Dover three times during his career, appearing on

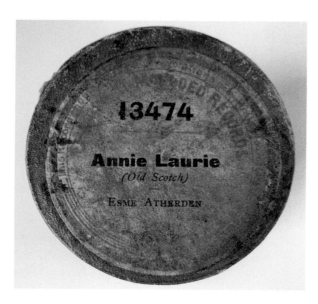

The lid of Esme Atherden's Edison record cylinder box, 1906.

Edison phonograph cylinder record box, 1906.

the Promenade Pier for one of their series of concerts in September 1901, and twice in the Town Hall in 1908. He was a widely travelled artiste, appearing at concert halls and piers for over twenty years between 1898 and 1920. He was retained by the Llandudno Pier Company for their 1899 season, and he also appeared in concerts as diverse as the Cheltenham Festival Society concert in October, 1907 and the Hull Postmen's Band concert in December, 1907. In December 1914 he was in a concert in aid of 'Our Indian Soldiers at the Front', and it was reported that his 'beautiful voice and ability have won for him such great fame, and who is in so great demand'. Like Esme, Gwilym recorded on phonograph cylinder for Edison, making seven recordings in 1907 alone.

The Promenade Pier Company also provided a French flavour for its audiences in the form of Monsieur Eugene Chochoix. When the pavilion opened the local newspaper recorded that, 'The programme also included a violin solo by Mons. Eugene Chochoin [Chochoix].' Born in Boulogne in April 1866, he moved to London in 1890, married an English woman, Clarissa Mills, in 1896, and gained British citizenship in July 1902. Like so many of these entertainers who travelled around, there is no known photograph of him, but his French military record of 1886 does tell us that he was 5 feet 6 inches tall, had auburn hair, grey/blue eyes and an oval face. In June 1906 representatives of the University of Paris visited London, and a reception was given at the French Embassy, with music provided by among others 'The Orchestra Chochoix'. In 1905 the *Musical News* reported that, 'Musician members of the French colony of London formed an orchestra with Mr. Chochoix as chef orchestra. This new orchestra is called "The Tricolore Orchestra", and French musicians living in London are cordially invited to join it.' Eugene Chochoix passed away in Margate in 1947, aged eighty-one.

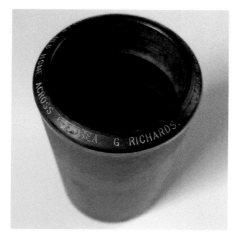

Edison phonograph cylinder record 'The Dear Old Home Across the Sea' by Gwilym Richards, c. 1907.

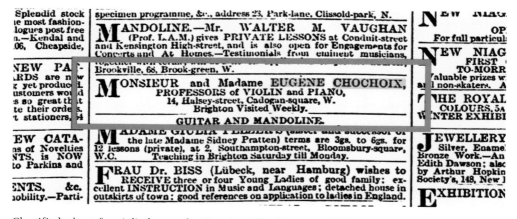

Classified advert for violin lessons by Monsieur Chochoix, 1900. (*The Morning Post*)

Of a more popular style perhaps than professional opera, but of no less importance to the audience, was Harold Montague (*c.* 1874–1932) and his troupe The Vagabonds. They appeared in Dover eight times between 1905 and 1927, although Harold often appeared on the stage alone. The Vagabonds who appeared alongside him did so dressed in a sort of comedic 'Merrie England' costume, and were true music hall performers. Their repertoire consisted of humorous songs, so-called 'pianologues', with Harold seated at the pianoforte and generally playing the fool. Harold was referred to as 'the jester of the evening' after one solo performance at the Town Hall in February 1906. Harold Montague also appeared by himself at the Royal Hippodrome Theatre in Snargate Street in March 1918 (which was to be lost to bomb damage in 1944), but performed with The Vagabonds both times he was at the pier. In June 1905 The Vagabonds consisted of Josephine Gordon, Ethel Mayaffre, Maud Harvey, Mr Leslie Burgess, David W. Norton and Percival Mackenzie. Later personnel would comprise Leslie Lulu, Olive Sparke, Claude Russell, Harry Merrylees, Kathleen Severn, Ernest Bertram, Hilda More, Jean Harley and George Barker.

Harold Montague was primarily a pianist but he also wrote at least twenty-seven songs, and recorded twenty-four of those on gramophone records between 1911 and 1918. Seven of these he recorded on the Zonophone record label, sharing the catalogue's pages with such music hall legends as Charlie Penrose and Billy Williams. His recorded pieces included such bizarre titles as 'Is There Nobody Else to Come?', 'The Lady and the Dog' and "When Maud Put Her New Bathing Costume On'. In June 1905 when The Vagabonds appeared in the pier pavilion the local newspaper reported that 'the programme included a comedietta by Harold Montague, "First Aid to the Wounded", in which he acted with Miss Ethel Mayaffre. This was capital. There was also a musical farce, "The Nihilist", in which nearly all the company took part. It simply teemed with fun.'

Harold Montague toured Britain's theatres from 1905 to 1927, singing, playing the piano and playing the fool, maintaining a music hall tradition that today is little more than a distant memory. He passed away in 1932 aged fifty-eight.

Our last famous musician to have played in Dover is the violinist Marie Hall (1884–1956). Born in Newcastle upon Tyne to a musical family (her father was a professional harpist), she showed natural talent for the violin at an early age, playing Bach at just ten years old. At the age of sixteen she played privately in London for the Czech violinist-composer Jan Kubelik (1880–1940), who was impressed enough with her ability to send her to Prague to further improve her technique with his friend and professional colleague Otakar Ševčík (1852–1934), where she stayed for eighteen months. Her first performance outside Prague was made at St James's Hall (London) in 1903 to rousing applause, and a year later she made her first sojourn to play at Dover.

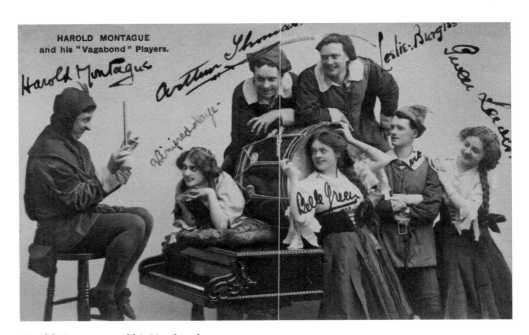

Harold Montague and his Vagabonds, *c.* 1902.

'My Beastly Eyeglass' sheet music by Harold Montague, *c.* 1902.

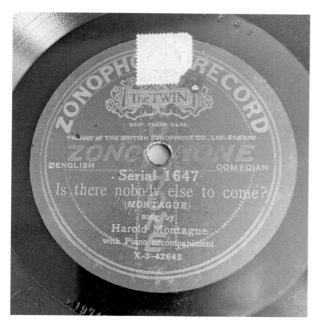

One of Harold Montague's recordings, 'Is there nobody else to come?', featured in the October 1917 Zonophone 78 catalogue. (October 1917 Zonophone 78 catalogue)

Violinist Marie Hall, *c.* 1920.

Between 1903 and 1920 she played six times at Dover, appearing at the Town Hall (April 1904, November 1908, March 1914 and March 1920), the Royal Hippodrome (March 1917) and on the Promenade Pier (August 1905). Her first performance in Dover had a large turnout, even though the local population wasn't used to paying so much for admission tickets. This concert in the Town Hall opened with Beethoven's 'Sonata No. 2' in C Minor for violin and piano, accompaniment being by notable pianist Herr Egon Petri (1881–1962). Marie also played Mendelssohn, Bach, Paganinni and finally 'Fantasia Bohemien' by her old teacher, Ševčík.

Marie's second performance in Dover at the Promenade Pier pavilion was less of a success. Because of the weather, which was wet and windy, the turnout was not as good as the previous year's. The local newspaper noted that in general 'sufficient appreciation is never shown as it ought to be by Dover audiences for celebrated musicians.' On this occasion she started the concert with Ernst's 'Concerto in F Minor', then followed with five more well-known pieces; Bach's 'La Complaisante', Couperin's 'Le Bavolet Flottant', Mozart's 'Minuet in D', Schubert's 'L'Abeille' and lastly 'Humoreske' by Dvorak. She finished the recital with some Bach and then 'Moto Perpetuo' by Ries. According to the newspaper, the audience would have liked her to have gone on and on, and it also noted 'the weird accompaniment' of the wind and weather outside the pavilion, which it thought rather oddly, brought an air of sadness to the evening.

It is no exaggeration to say that like Walter Hyde, Marie Hall was considered a celebrity of her day. She was the owner of what is today referred to as the 'Marie Hall Viotti', a violin built by Antonio Stradivari in 1709, and used by the Italian violinist Giovanni Battista Viotti (1755–1824) for his first Paris concerts in 1781. The composer Ralph Vaughan Williams's (1872–1958) piece for violin and orchestra, 'Lark Ascending', inspired by George Meredith's poem of the same name, was dedicated to Marie, and her name appears on the original manuscript. In her very early years she was taught personally by the composer Edward Elgar, and when she debuted in London in 1903 she was considered a 'real sensation'. In December 1916 she recorded a cut-down version of Elgar's 'Violin Concerto' for a violin and orchestra with Elgar conducting for HMV. The 1916 HMV publicity for the set of recordings stated that:

> The fact that these [recordings] have been made under Sir Edward Elgar's personal direction, and with himself conducting the orchestra, will make them not only prized today, but of historical value, since future generations will be able to learn the composer's own interpretation of his music. The soloist, Miss Marie Hall, has achieved many triumphs by her playing of the Concerto, her lyric beauty of tone and perfectly finished style suiting ideally from an interpretative point of view.

This opinion of Marie Hall was shared well into the digital era in a review in *Gramophone* magazine in 2004 when her playing was retrospectively described as being 'poised and exact, yet always maintaining a warm, appealing tone'.

[Photo : May & Miss Moore, Melbourne]

EDNA THORNTON as *Dalila*
in " SAMSON ET DALILA "

Another opera 'great': Edna Thornton, who sang at Dover on the Promenade Pier in September 1901. This photo was taken in 1921. (Opera at Home by HMV)

5. 'In the Early Days of the War...'

Granville Gardens on the promenade was another favourite music venue. Laid out by the Harbour Board in 1878, the gardens became a popular music and roller-skating venue from the late 1880s. They were run by a committee, presided over in 1888 by Sir Richard Dickeson, four times Dover's mayor, and were financed by a list of subscribers and by ticket revenue. At the end of year accounts 31 May 1888, subscriptions had raised £118 2s 6d,[19] the sale of tickets and weekly subscriptions raised 7 guineas,[20] and revenue at the gate totalled £124 11s 6d, £2 18s for the sale of programmes and chair hire, making a grand total of £250 19s. After costs, the Committee was left with 17s and 4d. There were two concerts a day in the summer; one in the afternoon, and another in the evening, the band receiving 30s for an afternoon's performance and £3 for an evening one – plus each bandsman received a free pint of beer! Performances for July 1888 were by the Royal Irish Fusiliers, the Royal Munster Fusiliers and the Buffs. While these concerts were going on in the Granville Gardens the town council had their own band playing in Pencester Park. It was thought that the class of person who wanted to hear the free town band at the park would be different to that paying to hear military bands on the seafront.

Unfortunately the gardens' fate was sealed along with the destruction of many of the properties on the seafront during the Second World War, but up to then the venue was a popular one. The Seaforth Highlanders were regulars during the 1930s and on 17 June 1934 they played to an estimated 1,000 people. They were there also during Cricket Week of 1931, playing alongside a plethora of other bands, and during the Dover Festival Week of June of that year. The Seaforth Highlanders were garrisoned at the Citadel on Western Heights from 1929 and went to the castle before moving to Palestine in 1933. On Easter Sunday 1935 it was the turn of the Royal Berkshire Regiment (garrisoned at Shorncliffe) to play in Granville Gardens. They were part of a season at the gardens (beginning Easter Sunday and lasting until 15 September) that included bands from the Duke of York Military School, the 2nd Battalion, the Dorset Regiment, the 2nd Battalion, the Devonshires, to name a few, not to mention the Louis Arnold Orchestra and St Hilda's Band.

Although set in wartime London, not peacetime Dover, the opening of Elizabeth Bowen's 'The Heat of the Day' draws a vivid picture of sitting in a deckchair, outside on a

19 £118, 2s and 6d, in total £118 and 12.5p.
20 £7 and 35p.

Granville Gardens with the Seaforth Highlanders taking a break between pieces, *c.* 1930.

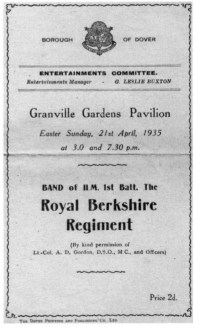

Above left: Seaforth Highlanders concert poster, *c.* 1930.

Above right: Programme for the 1st Battalion, Royal Berkshire Regiment, at Granville Gardens. Note the price of 2*d*, and that they're for sale not by the band, but the borough of Dover, 1935.

Programme of Music

Conductor - - - - - - - - - J. E. NEEDHAM, L.R.A.M., A.R.C.M.

AFTERNOON at 3 p.m.		
1	... "Martial Moments" ...	arr. *Winter*
2	Overture ... "Lustspiel" ...	*Keler-Bela*
3	Waltz ... "Blue Danube" ...	*Strauss*
4	Selection ... "Songs of Sullivan" ...	arr. *Godfrey*
5	Morceau ... "Salût D'Amour" ...	*Elgar*
6	Oriental Scene ... "Dervish Chorus" ...	*Sebeck*
7	"Pfeif Lied" from "Fruhlingstuft" ...	*Strauss*
8	Selection ... "Lilac Time" ...	*Schubert*
9	Serenade ... "My Pretty Jane" ...	*Bishop*
10	Selection "Viennese Memories of Lehar" arr.	*Hall*
11	Patrol ... "The Wee Macgreegor" ...	*Amers*
	GOD SAVE THE KING	

EVENING at 7.30 p.m.		
1	Introduction Act III "Lohengrin" ...	*Wagner*
2	Selection .. "Il Trovatore" ...	*Verdi*
3	Piccolo Solo "The Wren in the Poplars"	*Barsotti*
4	Waltz ... "Der Rosenkavalier" ...	*Strauss*
5	Male Voice Choir (a) "Hoodah Day" (b) "Fire Down Below" (c) "Hulla Baloo Balay"	
	INTERVAL (10 min.)	
6	Intermezzo "Cavalleria Rusticana" ...	*Mascagni*
7	Characteristic "Parade of the Tin Soldiers"	*Lessel*
8	Selection "Harry Lauder's Songs" arr.	*Ord Hume*
9 "Serenata" *Toselli*
10	Selection ... "Cavalcade" ...	*Coward*
	GOD SAVE THE KING	

Interior of Royal Berkshire Regiment programme, 1935.

balmy late summer evening, listening to a professional orchestra. When I first read it, it was Granville Gardens that I pictured:

> That Sunday, from six o'clock in the evening, it was a Viennese orchestra that played. The season was late for an outdoor concert; already leaves were drifting on to the grass stage ... the rows of chairs down the slope, facing the orchestra, still only filled up slowly ... people were being slowly drawn ... by the sensation that they were missing something ... the source of music was found to be also the source of dusk ... It was not completely in shadow – here and there blades of sunset crossed ... and lay along ranks of chairs and faces and hands. Gnats quivered, cigarette smoke dissolved. But the light was so low, so theatrical, and so yellow that it was evident it would soon be gone. The incoming tide was evening. Glass-clear darkness ... already formed in the thicket behind the orchestra. The Sunday had been brilliant ... the waltzes, the marches, the gay overtures ... now began to command this hourless place. To be sitting packed among other people was better than walking about alone. At the last moment, this crowned the day with meaning.[21]

In almost any photographic view of Granville Gardens stands the architectural splendour of the Grand Hotel. Before the hotel opened in 1893, the building was actually four separate houses. The Dover Grand Hotel Company directors were some of Dover's most upstanding citizens of the day: Sir Richard Dickeson, J. Stilwell, H. Hayward, A. Leney, H. Stiff and J. and F. Finnis. The local newspaper was given a guided tour of the hotel before it opened, and they commented favourably on the 'lift worked by hydraulic power', the luxurious carpets, dark mahogany furniture, the enchanting sea view with its accompanying 'whiff of the healthful ozone', and the plying of the ferries up and down the Channel. In addition, the so-called 'culinary department was up to date and efficient,' and there was a well-furnished billiard room and a well-arranged bar. The hotel officially

21 Bowen, E., *The Heat of the Day* (Penguin, London, 1976), p. 7–9.

The St Hilda's Band that played at Granville Gardens, *c.* 1927.

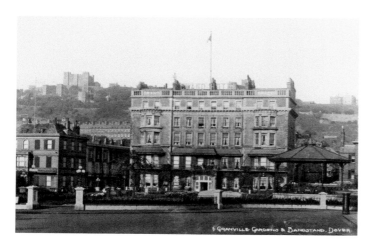

The Grand Hotel and Granville Gardens, *c.* 1912.

MENU.
Hors d'œuvres.
Huitres.
Tortue Clair.
Saumon. Sauce Crevettes et verte.
Whitebait.
Poulets Sautés à la Chevalier,
Ris de Veau en Caisses.
Punch Glacé à la Romaine.
Selle d'agneau à la Duchesse.
Jambon de York au Madère.
Cailles sur Canapés.
Aspic de Homard. Salade Française.
Asperges en branches.
Poudin froid à l'Italienne.
Gelèe aux Liqueurs.
Eclairs au Moka.
Glace à la Napolitaine.
Fruits.
Service à la Russe.
Liqueurs.
Chambertin, vintage 1886. Port, vintage 1870.
Chablis, punch, sherry, liebfraumilch, bollinger, vintage 1887.

Menu for the opening of the Grand Hotel in 1893. (*Dover Express*)

An advert for the Grand
Hotel, *c.* 1900. (*Views of Dover,*
W. Parsons)

opened with a grand banquet for many local dignitaries and even included the Royal
Inniskilling Fusiliers band playing during the dinner.

Sadly, on 11 September 1940 a quarter of the building came crashing down as a result
of a direct (or extremely near) hit by a German bomb. *Chicago Tribune* reporter Guy
Murchie (1907–97) was in Dover reporting on the war for the US newspaper, and was
on the top floor of the hotel as it was hit, with a *Tribune* colleague from London and two
naval officers. Murchie reports, 'I held my arms over my head instinctively. Everything
went black. I was fully conscious as the floor fell away under my feet ... as I dropped
into emptiness the air was black, full of soot. I expected to land on the next floor, but
to my surprise, I kept falling for many seconds. I waited, limply, feeling that this might
be the end for me ... then I landed.' It is not clear which floor of the hotel Murchie had
landed on, but he was covered in rubble. He goes on: 'gradually the air grew lighter as the
smoke and soot settled, and I could see I was tangled in a mass of timbers. The remaining
jagged walls towered upward some fifty feet and I was acutely aware of the possibility
of one of them falling on me.' After being dug free, Murchie and the other *Tribune* man,
Stanley Johnstone, shook hands and then began to dig out the hotel's receptionist whose
leg was broken and trapped by debris. Johnstone was unharmed, but Murchie and the
receptionist were later taken to the same hospital. Of the two naval officers present with
Murchie when the bomb hit, only one survived. Nearly a week later on 17 September, the
funeral of Lieutenant William John Lunn RNR,[22] one of the naval officers that was with
Guy Murchie in the Grand Hotel, was held. Lunn left a widow, Minnie Frances Lunn,
in Llandudno. He is buried in St James's Cemetery. After the war Murchie had a varied
career: with the newspaper, as a flying instructor, and wrote several books about science,
religion and philosophy.

22 RNR – Royal Naval Reserve.

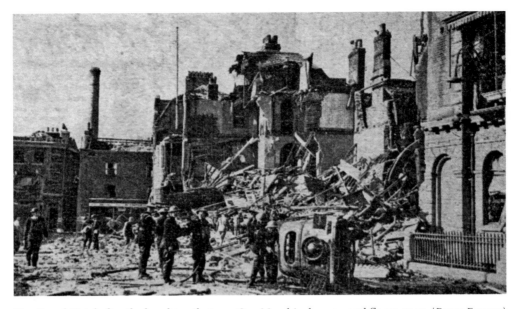

The Grand Hotel after the bombing that saw Guy Murchie drop several floors, 1940. (*Dover Express*)

The headstone of Lieutenant W. J. Lunn at St James' Cemetery, 2018.

A British journalist in Dover during 1940 was *Daily Herald* reporter Reginald Foster (1904–99). He was asked by the *Herald* to go to Kent and see the newly formed paratroop regiment. He ended up in Dover and stayed there for well over a year, witnessing the enemy shelling, bombing, the Battle of Britain and the threat of invasion. In 1941 he wrote a book of his experiences in this frontline town, described by the local newspaper as 'An exciting story of exciting times is Reginald Foster's *Dover Front*.' In 1941 the thirty-seven-year-old Foster had been a career newspaper man for twenty years, and had been with the *Daily Herald* on and off since 1932 and was the *Herald*'s special correspondent at Dover during the war. Foster tells us how newspaper men had to be careful even in those relatively quiet days of the 'Phoney War', when nosing around for stories in such a heavily garrisoned town as Dover; he calls to mind the old wartime poster with that unambiguously poignant reminder that 'Careless Talk Costs Lives', and how on at least one occasion he was summoned for interview by local military officials.

The book is a good read even after all these years, the narrative skipping along at an enjoyable pace, and includes some notable highlights that deserve mention here. On 30 May, Foster went to Canterbury 'and dictated the story that told for the first time that many thousands of the British Expeditionary Force (BEF) men had been brought safely home'. Following the fall of France during the early summer of 1940, the BEF retreated to the channel port of Dunkirk. Codenamed 'Operation Dynamo', the resultant heroic evacuation of much of the British and Allied fighting forces was made possible by the now famous *ad hoc* flotilla of so-called 'Little Ships', orchestrated by Admiral Bertram Ramsey

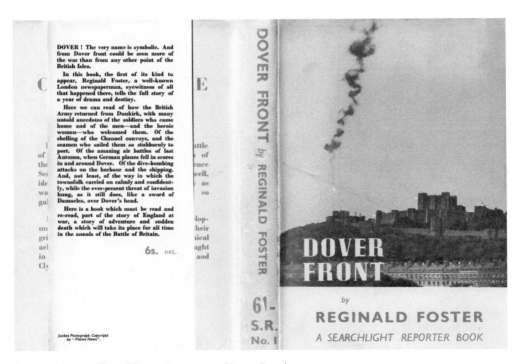

Cover and cover flap of *Dover Front*, 1940. (*Dover Front*)

from the cliff casemate tunnels under Dover Castle. On 31 May, the War Office had arranged for Foster and his fellow journalists to have access to the harbour in order to see first-hand the men coming off the armada of 'Little Ships'. Foster notes that the men he saw disembarking the boats and ships were ordinary looking, but he means it as a measure of the 'grit' of the rank and file; these were 'the little ordinary men from a hundred trades, who lean over a garden fence to borrow a mower and chat for half an hour in doing it. The men who rush for the 8.45 or cram the early buses and take the dog for a walk on Sunday. Just the ordinary men of the street, or town and village. These were the Britishers who astonished the world and themselves and made us poor spectators stand for days with wonder in our eyes and hearts.'

Dover Front also gives references to many local people and places, traces one can still detect today if one looks in the right places. James (Jimmy) Cairns, Dover's wartime mayor, of course, is mentioned (and to whom this writer is related). Also here is Deal-born F. C. Overton, who famously ran dances in the Town Hall that carried on until midnight while Dover was being bombed. After the war Overton was a local councillor, and in 1949 was picked as one of the judges for the Earl's Court Star Ballroom Championships. Foster notes Leonard Deverson, who ran a hairdresser's at No. 23 High Street, and who was killed by a bomb splinter in November 1940 while protecting a woman on the street from the attack. He had just left his salon and was on his way to go on duty (as a fire-watcher or similar wartime occupation). Mr S. L. Buxton was managing the skating rink until it was damaged, so he turned his hand to managing a cinema instead. Foster could have been mistaken and was referring to George Buxton, who in 1939 is listed as living at No. 8 Northampton Street, and is described as being an entertainments manager for the local borough. 'Old Richard Chapman', the town sergeant, crops up also. In 1940 he had been doing this job for thirty years, and apparently his father did the job for thirty-six years before him. John Richard Chapman (he must not have liked his first name) was bombed out of his home at No. 21 Priory Road in 1943, then again in Park Street. Apparently he was a little shaken but went to work the next day! During his tenure he saw sixteen mayors, many royal families and heads of state, and three Lords Warden installations. Chapman was succeeded as town sergeant by Mr Reginald Cyril Frederick Leppard, a house decorator of No. 4 Russell Road, Folkestone, in 1945.

Following the last men arriving home from Dunkirk in June, there was a period of quiet in Dover. 'Dover yet had to experience bombing,' says Foster. People got back to their routines, the town's businesses resumed a degree of normality, and Dunkirk was seen as a victory. For Foster, Dover's war started on 7 July when the biggest raid so far was seen over Dover and Folkestone. Around seventy planes, Spitfires and Messerschmitts fought over the coast at relatively low altitudes, and many townsfolk went to the cliff edge to get a better view of this new spectacle: 'Overhead was being fought one of the most spectacular dogfights I have ever seen – and since that day I have seen hundreds.' This, of course, was the start of the Battle of Britain, Herr Hitler's supposed end goal being an invasion of Britain.

In early July 1940, Hitler issued 'Directive No. 16 for Preparations of a Landing Operation Against England', otherwise known as Operation Sealion. Given the Royal Navy's superiority of numbers over the German navy (Kriegsmarine), an invasion could only go

Right: Leonard Deverson's hair salon at No. 23 High Street, 2019.

Below: Alderman Jimmy Cairns on Dover seafront, 1940. Note the pillbox to the left. (*Dover Front*)

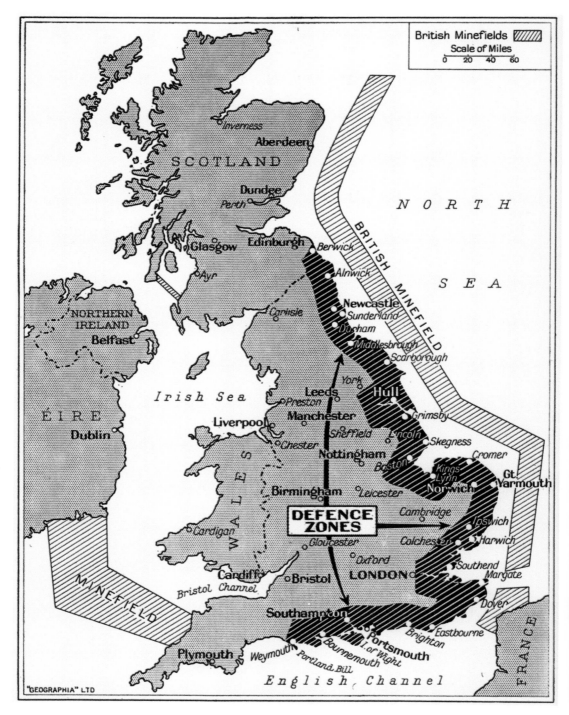

A map showing Britain's 1940 'invasion coast'. (Hutchinson's *Pictorial History of the War*)

WIR FAHREN GEGEN ENGELLAND

DER KLEINE INVASIONS- DOLMETSCHER	PETIT MANUEL DE CONVERSATION POUR L'INVASION	TAALCURSUS ZONDER LEERMEESTER VOOR DUITSCHE SOLDATEN
I. Vor der Invasion	**I. Avant l'invasion**	**I. Vóór de invasie**
1. Die See ist gross — kalt — stürmisch.	1. La mer est vaste — froide — houleuse.	1. De zee is groot — koud — stormachtig.
2. Wie oft müssen wir noch Landungsmanöver üben ?	2. Combien de fois encore devrons-nous faire des exercises de débarquement?	2. Hoe vaak nog moeten w'exerceeren om 't landen op een kust te leeren ?
3. Ob wir wohl in England ankommen werden ?	3. Pensez-vous que nous arriverons jamais en Angleterre?	3. Zullen we ooit in Engeland komen ?
4. Ob wir heil zurückkommen werden ?	4. Pensez-vous que nous reviendrons jamais d'Angleterre?	4. Zullen we heelhuids wéerom komen ?
5. Wann ist der nächste englische Luftangriff? Heute morgens ; mittags ; machmittags; abends; nachts.	5. Quand le prochain raid anglais aura-t-il lieu ? — Aujourd'hui, dans la matinée, à midi, dans l'après-midi, dans la soirée, dans la nuit.	5. Wanneer komt de volgende Britsche luchtaanval ? Heden — morgen, middag, namiddag, avond, nacht.
6. Warum fährt der Führer nicht mit ?	6. Pourquoi est-ce que le Fuehrer ne vient pas avec nous ?	6. Waarom reist de Führer niet met ons mee ?
7. Unser Benzinlager brennt noch immer !	7. Notre dépôt d'essence continue de brûler !	7. Ons benzinedepot staat nog steeds in lichter laaie !
8. Euer Benzinlager brennt schon wieder !	8. Votre dépôt d'essence a recommencé à brûler !	8. Uw benzinedepot staat alweer in lichter laaie !
9. Wer hat schon wieder das Telefonkabel durchgeschnitten ?	9. Qui a encore coupé notre ligne téléphonique ?	9. Wie heeft onze telefoonleiding nou weer doorgeknipt ?
10. Haben Sie meinen Kameraden in den Kanal geworfen ?	10. Avez-vous jeté mon camarade dans le canal ?	10. Heeft U mijn kameraad in de gracht gesmeten ?
11. Können Sie mir eine Schwimmweste — einen Rettungsring — leihen ?	11. Pouvez-vous me prêter une ceinture, — une bouée de sauvetage?	11. Kunt U mij een zwemvest — een reddinggordel leenen ?
12. Was kosten bei Ihnen Schwimmstunden ?	12. Quel prix prenez-vous pour les leçons de natation ?	12. Hoeveel kost het om bij U zwemmen te leeren ?
13. Wie viele Invasionsfahrten brauch' ich für das E.K.I ?	13. Combien d'invasions dois-je faire pour recevoir la Croix de Fer de Jère classe?	13. Hoe dikwijls moet Ik aan een invasietocht meedoen om het IJzeren Kruis te winnen ?
14. Sieben — acht — neun.	14. Sept — huit — neuf.	14. Zeven — acht — negen keer.
15. Wir werden gegen Engelland fahren !	15. Nous partirons pour l'Angleterre ! (Qu'ils disent.)	15. Wij zullen gauw naar Engeland varen ! (Plons ! Plons ! Plons !)
II. Während der Invasion	**II. Pendant l'invasion**	**II. Tijdens de invasie**
1. Der Seegang — Der Sturm. — Der Nebel. Die Windstärke.	1. Le gros temps — la tempête — le brouillard — la violence de l'ouragan.	1. De deining — de storm — de mist — de orkaan.
2. Wir sind seekrank. Wo ist der Kübel ?	2. Nous avons le mal de mer. Où est la cuvette?	2. Wij zijn zeeziek. Waar is de kwispedoor ?
3. Ist das eine Bombe — ein Torpedo — eine Granate — eine Mine ?	3. Est-ce une bombe — une torpille — un obus — une mine?	3. Is dat een bom — een torpedo — een granaat — een mijn ?

British propaganda anti-invasion leaflet to be dropped on Germany, 1940. (Hutchinson's *Pictorial History of the War*)

ahead if the German airforce (Luftwaffe) could first provide control of the skies. During this period invasion was expected and Britain's defences were drastically augmented. For example, 153 new coastal gun batteries were completed by the end of 1940, some along the coast of Dover and St Margarets, the sites of which can still be visited today. Barriers and mines were laid in open coastal areas, mustard gas was stockpiled, 'stop lines' were mapped out as strategic points across the countryside, which were reinforced with the ubiquitous brick and concrete 'pillbox', and other forms of defence in preparation for a German force landing elsewhere.

One area of Dover where several elements of these defence systems can be seen is in a wooded area in Old Charlton Road next to the Lower Danes playing field. There are two pillboxes, what is probably a field gun emplacement, an anti-tank ditch and some anti-tank obstacles. This concentration of defensive structures is not random, nor is it isolated. These structures formed part of the South East Command (XII Corps) stop line (East Kent), and were designed to offer resistance to an enemy force that had already landed to the north-east of Dover, where the shoreline does not butt up to the cliffs. Moving south, the anti-tank ditch or its associated structures continued across Old Charlton Road and joined up with Fort Burgoyne and then terminated at the Northfall Meadow behind Dover Castle, where there are still Spigot Mortar and field gun emplacements. Moving north, the Dover to Deal railway cutting that runs next to the Danes playing field provided a ready-made anti-tank obstacle that was integrated into the design of these local defences. From here the stop line defences would have continued towards Whitstable, thus cutting off the Kent hinterland and London from an enemy advancing from low-lying coastal areas.

The ubiquitous brick pillbox is a common sight in East Kent, and in Dover there is a good range of them. The most common type to be found on the hills covering the main

Two remaining anti-tank obstacles still in situ at the Danes playing field, 2019.

Anti-tank obstacles 'somewhere in
England', 1940. (Hutchinson's *Pictorial
History of the War*)

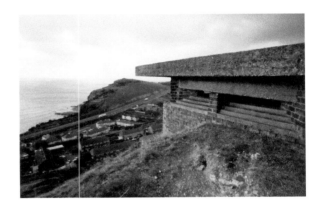

Dover Type pillbox overlooking
Aycliffe from Western Heights, 2000.

Dover Type pillbox overlooking the Folkestone
Road from Western Heights, 1999.

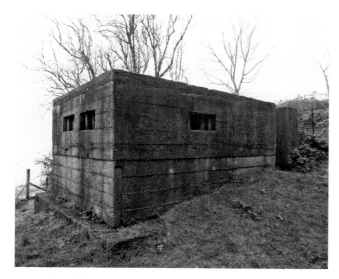

Above left: Type 23 pillbox at St Martin's Battery, Western Heights, 2018.

Above right: Spigot Mortar mounting at Citadel Battery, Western Heights, 2000.

roads into town is known as the 'Dover Type' and this is peculiar to Dover. These are square buildings, loopholed for small arms fire, with overhanging reinforced concrete roofs. The Dover Type can be seen on Western Heights along with the Type 23, which has a main enclosed roofed section suitable for a garrison of five men and a maximum of four light machine guns. There is also an 'outside' section enclosed on four sides, which has a mounting for an anti-aircraft gun. This mounting takes the form of a 6 foot 6 inch steel pole.

It may be interesting to note in 'Tactical Notes for Platoon Commanders, 1941...Strong posts' [Pillboxes] that:

> The concrete pillbox is a great aid to defence if intelligently used; if not, it may become a death trap ... concrete is a protection against bullets, shell splinters and weather. Sometimes it affords protection against shellfire. If properly camouflaged it is also protection from ground and air observation ... many concrete posts are not complete protection against a direct hit from a shell or aerial bomb. They all have the disadvantage of limiting the field of view and the field of fire. The garrison will be unable to use all their rifles at one and the same time because of the fewness of the loopholes. Finally the garrison is hindered in the employment of the hand grenade and bayonet.

One further element of the defensive works at Old Charlton Road was a 'flame fougasse'. This was an offensive weapon developed by the government's Petroleum Warfare Department, whose aim was the development of anti-invasion weapons based on propelling ignited petroleum spirit at the enemy. The flame fougasse entailed several 40-gallon barrels filled with an oil/petrol mixture, typically hidden in a hedgerow, which

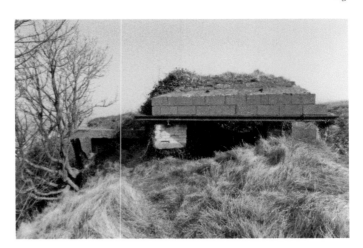

Hybrid pillbox-cum-shelter
at Citadel Battery, Western
Heights, 1994.

when detonated would have sent liquid burning oil pouring down the hill. Sadly, there is no longer any physical evidence of this installation. The PWD also came up with some specifically designed flamethrowers for operation by the Home Guard and the flame barrage, which was used to set light to an invasion beach. In Kent this last weapon was tested at Dumpton Gap along the coast from Dover, also at Deal and at Studland Bay in Dorset. Tests carried out in January 1941 resulted in less than favourable results: 'Though some of the oil pools ignited, they broke up rapidly into errant fractions which had nothing of the formidable qualities of the complete barrage, and in many cases were extinguished by the surf.'

It was no less a disaster when the system was tested in Deal the same year: 'Occasionally we were bombed, and the long-range guns from Calais turned their attention in our direction. The climax came when a north-easterly early in January 1941 altered the whole configuration of the shingle, tore up the lines of Admiralty scaffolding to which our pipes had been anchored and threw back the Sea-Flame Barrage into our laps, a mass of twisted ironmongery.'

By March 1941 the system had been perfected. In all, 10 miles were installed along the 'invasion coast': between Kingsdown and Sandwich, at St Margarets, Shakespeare Beach, Rye and Studland Bay. The three Dover flame barrage oil storage tanks were rediscovered in the early 1990s when the A20 extension road was built. They were languishing under fifty years' of earth and nettles in the lower end of the Western Heights South Lines ditch, today where the Megger (AVO) roundabout is located. Samples taken from the tanks at the time by the local Trading Standards Officer (Harry Howe, formerly of Dickson Road, Tower Hamlets) revealed that they still contained a highly flammable oil-based mixture. Sadly, the tanks and pumping house were removed and around half of the south lines ditch demolished to make way for the new road.

One 'invasion' of these isles that did go to plan was in 1888 and was effected by the subterfuge of a combined Franco-Russian fifth column. *The Taking of Dover* by journalist Horace Francis Lester (1853–96) tells of an effort to take command of Dover Castle and the rest of the town's fortifications as part of a nationwide *coup de main*. This story is

The effects of the flame
barrage at Studland Bay,
Dorset, 1940. (*Flame
Over Britain*)

The remains of a
flame barrage pipe on
Shakespeare Beach, 1995.

Removal of flame barrage
tanks at south lines ditch,
Western Heights, *c.* 1992.
(Paul Hewlett)

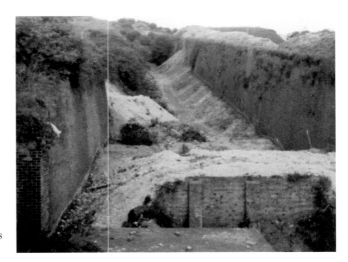

South lines ditch, Western Heights, taken from the bridge over the A20 during PWD tanks removal, c. 1992. (Paul Hewlett)

GERMAN AMMUNITION TRAIN.

Making use of modern technology helped the Prussian forces to mobilise quickly and keep their supply lines fed, c. 1871. (Cassell's *History of the War between France and Germany* vol. 1)

one in a long line of so-called 'invasion fiction', which was encouraged by the success of the *Battle of Dorking*, another such work, written by George Tomkyns Chesney (1830–95) and published in serial form in 1871. Chesney wrote this earlier work hoping to draw to the attention of the government and military the poor state of Britain's defences at the time. The *Battle of Dorking* was published on the coat-tails of the Franco-Prussian War of 1870/71, and the almost Blitzkreig-like way in which Prussian forces mobilised and overran the French to victory.

The story, which is set a decade hence, is told by an unknown Frenchman who is writing from a future-subjugated England to his son in France. The son, who is at military college, has to prepare an essay entitled 'The Best Means to Gain Possession of a strongly Fortified Position in a Neighbouring Country', and the father's letter tells him of his part in this country's downfall. Unlike the *Battle of Dorking* story,

the downfall of England is brought about by a fifth column of men who are already here going about their business, silently awaiting orders to spring into action. The whole is choreographed by two men who come to Dover posing as gentlemen (in the old-fashioned sense of the word), the Russian as a Monsiur Schulzitska (real name Mirakoff), and the narrator as a ficticious French aristocrat, the Vicomte d'Yverne. The two men create a pretence of respectability, 'taking apartments in the most expensive and fashionable hotel in Dover' (almost certainly the Grand or the Burlington), and make themselves known to Dover's military officer circle. The date for the fifth column to spring into action and take over England is Boxing Day 1894. The conspirators argued that the British authorities would be at their least alert on this day because 'the English make it a point of religion to indulge in inordinate eating and drinking' over Christmas.

Before executing the plan on Boxing Day the couple have to become accustomed to the lay of the land, and this the Vicomte d'Yverne (the narrator) describes to his son:

> Dover is a most remarkably situated town; it is in a deep hollow between a line of chalk hills. On the left, as you advance down the High Street to the harbour and shore, rises the Castle Hill, with the Castle and its picturesque tower [the Keep] ... it is a magnificent specimen, this Dover Castle, of an old Norman citadel, with 'keep', inner and outer courts, gates and watch-towers, still much as they were when first made. The Castle Hill lay on the left, or north side, and on the right rose another line of hills, divided by nature into 'the Heights', a little distance from the sea and skirting the Folkestone Road, and Hay Hill, or Shakespeare's Cliff, abutting right upon the shore.

In order to subjugate the Dover defences they have to become familiar with them, and apparently this is not as difficult as it might seem. Firstly, the pair ingratiate themselves with the officers of the garrison. Secondly, 'Mirakoff and I were allowed [to visit the forts] because we were inoffensive foreign citizens,' and because the officers were very proud of their fortifications and believed that they were unassailable. In order to overthrow the military authorities in Dover on Boxing Day, the two men arrange a grand ball for them. The story doesn't say where, but one gets the impression that it is at the Maison Dieu.

While the officers of the Dover garrison are enjoying the festivities the two saboteurs sneak out and with the aid of hundreds of fifth columnists, ascend the two staircase shafts within the cliffs and overthrow the garrisons at the castle and at Grand Shaft Barracks. The stair shaft within the cliff that leads to the castle is described as 'a winding path down the cliff, leading directly into one of the streets of the town, called East Cliff Terrace.' This is a reference to the Guilford Shaft that exits the cliff behind where the old army recruitment building used to be, and the Grand Shaft Barracks is accessed by the Grand Shaft on Snargate Street, which is described as having 'three spiral flights of stairs, 420 steps in all, winding round and round'.

The author is obviously not that *au fait* with the area as he seems to think the cliff is twice its actual height. When the saboteurs reach Grand Shaft Barracks they let hundreds more men through one of the sally ports and take the British soldiers captive:

I and the others rushed on, avoiding the barracks, avoiding the amoury, to a small court close to the officers' quarters, on the south side of the fortification. Here, as I knew, was a postern [sally port] connecting directly with a part of the deep moat which ran around the works. We only met one man as we raced forward – a sleepy artilleryman, coming out of a door in his shirt sleeves and forage cap. My sword was through him before he had time to give the alarm. As yet there was no opposition, and no cry to show we were discovered. We reached the postern safely, and opened it with ease. I drew back the bolts, and then, my son, I fervently thanked Heaven that had guarded us hitherto. For outside that postern, lying along the grassy hillside right up to the lip of the moat, were five hundred of our men, armed to the teeth. As I opened the small gate, and gave the agreed signal, suddenly the grass became alive with men, who slid, climbed, tumbled to the bottom of the deep trench, and then rushed forward. Ah, I knew we were safe then. As I stood there, cheering them on, and saw them dash boldly into the fortress, with eyes gleaming and teeth set, I gloried in the skill which had, under Providence, directed us so far.

Above left: The bottom of the Guilford Shaft, the staircase from the seafront up into Dover Castle, 1993.

Above right: The type of armour-plated, loopholed doors the aggressors would have been up against to gain access to the castle, 1993. These doors were of sheet steel sandwiched in timber.

The postern connecting Grand Shaft Barracks to the town, 2019.

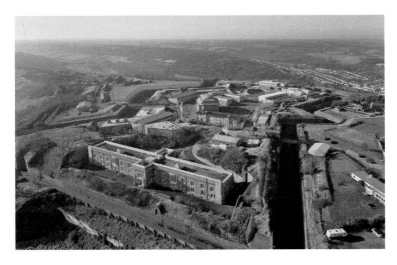

The Citadel from the air, 2019. (Adam Cowell)

These two staircases within the cliffs exist but the author invents a new fort situated on Shakespeare's Cliff, which is connected to the Citadel on Western Heights by a long tunnel. The saboteurs also take control of this.

The tale ends with 130,000 men having arrived across the Channel and England is lost: 'I cannot but pity the nation; but their humiliation, as it was occasioned by sheer recklessness, by avarice for the gains of trade, and by blind stupidity, appears to my judgement to have been fully deserved.' The weakest point in an otherwise great story is the fact that the Royal Navy is nowhere to be seen, and the author doesn't explain why.

Only three years before the Franco-Prussian War there was a battle being fought on British soil and on several fronts, and this battle would go on for decades. It was fought

at Dover, Brighton and Portsmouth and other towns across Britain. Although this meant the mass-mobilisation of troops and the readying of gun batteries, forts and the emptying of armouries across the country, the forces involved were all British, for this was the regular Easter Volunteer Review. These reviews were essentially mock battles involving thousands of men, horses, warships, guns, forts and they drew hundreds of spectators. Dover being the 'Key to the Kingdom', it was an obvious invasion point (as we have shown), so having a mock-invasion here made perfect sense. These battles were 'fought' at Dover irregularly from 1867 for nearly thirty years, the participants travelling from all over the country to take part.

Rising political tensions within the British government were among the main factors that spurred the creation of a new volunteer movement in 1859. Advancements in ship propulsion using steam power, naval armour plating, breech-loading rifled guns, and another Napoleon in France all contributed towards spasmodic invasion scares from the 1840s onwards. Any fears there were of a French invasion were given momentum by the British press and Britain's military was not considered to be up to the job of repelling an invasion force; she lacked a large enough regular army to manage her overseas possessions and protect the coast at home, and the Royal Navy was not known for its technical innovation at this time. Following Napoleon III's *coup d'etat*, the following editorial appeared in the *Times* in January 1852:

> We are told the French people are averse to war. The French people! What matters the disposition of the French people? ... [I]f M. Bonaparte could control the army, which has made him, we do not believe that a state of rest could be his policy ... England is a more tempting quarter in several respects. She is thought to be ill-prepared for war, and her population is unjustly deemed un-warlike, because unpractised, inexperienced in war ... England is the only country in which a free opinion is exercised on the conduct of M. Bonaparte.

The volunteer movement can be seen as the equivalent of today's Territorials. Ordinary shopkeepers and artisans (tradesmen) were encouraged to join so long as they could afford to pay a subscription and buy their uniforms. The local gentry usually provided the officer class, although the financial 'goal posts' were often moved in order to encourage recruitment. The movement was also not without its rallying poetry. From Alfred Richards' 'Our Volunteers':

> We are not armed to carry war
> To near or distant land,
> To steep the smiling globe with gore
> Or prowl with hostile band.
> But we are trained with trust above
> To guard our native coast,
> Our Queen, our fame – the home we love,
> And those we love the most.

NAPOLEON III., EMPEROR OF THE FRENCH, IN 1870.

Napoleon III, Emperor of France, *c.* 1871.
(Cassell's *History of the War between France and Germany* vol. 1)

The Easter Volunteer Reviews were always given pages and pages of the most excruciating detail in both the local and national newspapers, and the April 1867 review at Dover was no exception. The local 'paper reported that the Market Place and Bench Street both had triumphal arches erected which were illuminated with gas at night, and that although it was raining, townsfolk stayed out late armed with their umbrellas, but that the fireworks were a flop. Coloured emblems were hung out at every street (presumably an exaggeration); houses had emblems, mottos and inscriptions hung at windows. The illustrated papers of the time also show hundreds of spectators lining the volunteers' various processions and surrounding the 'battle' fields. Official figures reported that 24,034 military personnel were present, of which there were 175 men of the Royal Artillery, 1,154 from line regiments (regular soldiers) of the 51st and 76th Regiments and the 6th Depot Battalion. The remainder were from volunteer corps.

Logically enough, the 24,000-plus force was divided into two bodies: the invading and the defending force. The invading force was made up of the 1st and 2nd Divisions of infantry along with two batteries of field artillery and the 1st Brigade of Volunteer Field Batteries. They started out at a position north-east of the castle, some way east of the eastern outwork of Fort Burgoyne. The defenders, comprising the 3rd and 4th Infantry Divisions, the 2nd, 3rd and 4th Brigades of Artillery and around 200 cavalry formed up in front of the fort. The ground between them was Broad Lees Farm. The start of the battle was signalled by the firing of a cannon on the keep roof of Dover Castle, at which the defending force sprung into action against their aggressors, supported by 42 pounder cannon firing from Bell Battery within the castle. After fifteen or so minutes of this, several warships were spotted coming round the coast from the direction of Deal: 'the four war steamers approached Dover in a manner so menacing as almost to delude the spectator into the belief that a real enemy was coming down upon the town.'

A group of rifle volunteers at camp, *c.* 1878.

HMS *Martin,* part of the naval squadron of the 1867 *Dover Volunteer Review, c.* 1890. (US Navy photo courtesy of Naval History and Heritage Command)

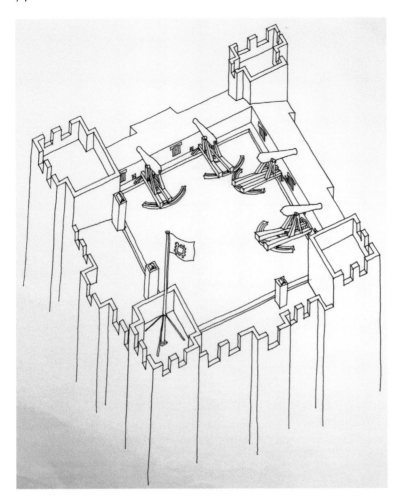

Suggested Dover
Castle keep roof
remodelling
with artillery
positions, *c.* 1994.
(Richard Linzey)

The newspaper goes on to describe the ships' advance, and I think in doing so manages to capture the drama of what must have been a very impressive sight:

two of the 68 pounders on the top of the Keep had joined in the firing ... having brought her Armstrongs[23] within range of East Cliff, Captain Commerell gave the order for firing. The [HMS] *Terrible* at once discharged a broadside of her enormous metal, which was replied to so rapidly by four 42 pounders on the East Cliff that the smoke of the opposing guns met over the sea ... But the Terrible was sufficiently far out to be covered by three 40 pounder Armstrong[s] placed on the drop redoubt upon the Western Heights at the other end of the town.

23 Large cannon manufactured by Armstrong, firing a projectile weighing 68 pounds.

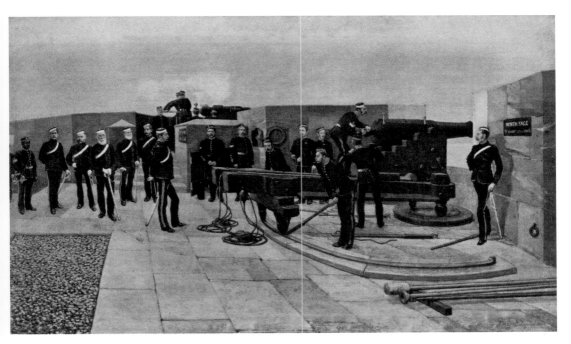

Volunteer coast artillerymen with a rifled muzzle-loading gun, 1878. (RUSI Journal No. 514, May 1934)

When all four ships had rounded the cliff, 'some 65 guns, ranging from 18 pounders to 68 pounders, were now booming from the forts with their fire directed at the squadron, while five or six others were joining in the fight on land'. As far as the newspaper was concerned, the sea forts battle eclipsed the land battle.

The local newspaper decreed that 'the men who have enrolled themselves for the defence of their country were afforded an opportunity of actually rehearsing the very duty which they will be called on to perform should England ever need their services in resisting an invader ... every year that this organisation is kept up to its present efficiency a new body of recruits receives military training, and in the end there will be a body far larger than the Regular Army capable of acting in defence of the country'. By 18:00 hours trains were waiting to take the volunteers back to their homes, and the platforms were clear by 21:00.

6. 'Dover Naturally Came in for a Good Deal of Attention at the Hands of the Authorities'

The 68-pounder guns that opened fire at HMS *Terrible* in 1867 from the roof of the castle's keep are of course long gone, but for today's casual visitor, Dover Castle Keep, or the Great Tower as it is known these days, must still be the focal point of the castle. It is well known within Dover Castle staff circles that visitors often ask 'where's the castle?' when they're down at the south end of the site, near the officers' barracks or the NAAFI restaurant. Perhaps this isn't surprising because, after all, the keep is the 'keep of last resort', the Citadel, the 'centre' of the twelfth century castle that is at the heart of this now multi-period site. The origins of Dover Castle are inexact. The site was probably an Iron Age[24] hill fort, then many centuries later, perhaps an Anglo-Saxon stronghold. When Duke William of Normandy spent just over a week there in 1066 strengthening existing defences, those defences were probably Saxon works of 1064 that centred around a motte,[25] with church and pharos at its centre. The British castle as we know it today is an import from Normandy, many of those starting life with keeps built of timber rather than stone. If indeed there was a fortification on this hill immediately pre-1066, it was likely to have been in the form of a burgh, a fortified town (from where we get the word 'borough' and the suffix 'burg' and 'bury', as in Canter*bury*). The Great Tower dates to Henry II (1133–89) and between 1180 and 1186 official records show expenditure of almost £1,100, a large proportion of this being spent on building the keep and inner ward (Keep Yard), presumably replacing an earlier timber keep, among other things.

The keep is 83 feet tall and almost 100 feet long on each side (plus the fore-building entrance), and in some places the walls are 20 feet thick. It has three floors including the basement, but the second floor is without doubt the grandest, with two main rooms being of double height, and since the 1790s being capped by two impressive brick vaults. The original roof structure of the keep would have comprised a lead roof enclosing a timber framework, and the inside of this structure would have been visible from the second floor, and would have made the two main spaces beneath even larger. The brick vaults

24 Iron Age in the United Kingdom was *c*. 800 BC to AD 43.
25 A motte-and-bailey fortification consisted of a raised motte or bank and a timber keep, with a walled bailey or settlement below. In times of trouble the settlement's population would hold up in the motte.

were all part of the castle's modernisation as carried out under the eye of Royal Engineer William Twiss. The new vaults had the double benefit of protecting the interior of the keep from plunging mortar fire (bombproofing) and being strong enough to take heavy artillery mounted on it.

The history of the keep is more convoluted than space here allows, and this is equally true of just its roof. The most drastic change to William Twiss's roof in recent years was made during the late 1990s, when it was stripped back for rebuilding and new rain water drainage was fitted. This may not sound very illustrious, but there are probably many of us who can recall seeing rain water running down the inside of the keep staircases and walls. Various works have been carried out to the keep roof over the years, including a new asphalt surface in February 1907, and in the early 1930s remedial building works were carried out prior to the installation of a giant water tank that took up most of the roof space. This tank was removed in 1962 and around 20 years later the roof was paved and a waterproof membrane fitted.

However, a water leak into the interior of the keep in its eastern corner can be seen in photographs taken as early as 1932, and leaks have since been attributed to a complex set of problems. In 1963 the works filled up working gutters, which were then unable to remove rain water; the remains of chimney flues beneath modern surfaces admitted water into the building; the 1983 repairs were not watertight and to a possibly lesser degree, water that did make it past the roof soaked into the thickness of the keep's walls, filled voids, then overflowed into the keep and the turret staircases were saturated with water.

A contract dated February 1996 detailed the work to be carried out to the keep roof, and this involved many complex processes, the details of which aren't an exciting read – the photo of these works in progress are far more dramatic. Repairs to the roof of the keep have transformed it, especially the removal of the raised level walkway of old by bringing the centre up to the same height, complete with new drainage and new chimney flues. The contractor's 1996 bill came to £106,614.41.

On 29 October 1859 the local newspaper reported that 'the works for the enlargement of the Drop Redoubt have been commenced this week ... the works are being carried out by Messrs. Stiff and Richardson.' Exactly 140 years later building works were once more going on at the fort, but this time it was not the War Department paying for them, but the new owners, English Heritage. This fort at the easternmost point of the Western Heights was built during the Napoleonic Wars, and is contemporary with the Citadel, the Grand Shaft and the Military Hospital at Archcliffe. A plan of the hill in the National Archive dated 1787 clearly shows substantial earthworks probably with timber revetments, in two areas, one approximately at the site of what is now the Citadel and another roughly where the Drop Redoubt is today. As already mentioned, these were laid out in the late 1770s. From these humble beginnings Dover has inherited a complex set of multi-period fortifications that are among the largest and most impressive in Europe.

Having been adapted and used during the Second World War, the Western Heights defences were officially decommissioned in 1956 when 'in the light of modern weapon developments' coast defence officially ended. For the next four decades the Drop

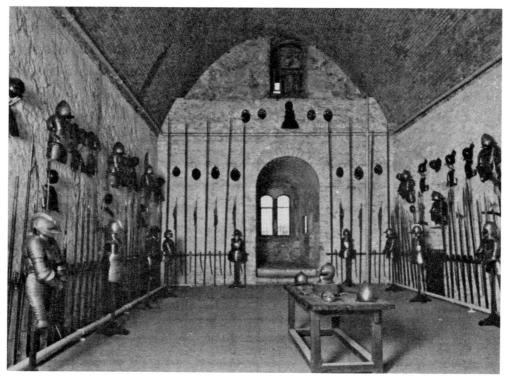

Dover Castle keep interior showing the brick-vaulted roof, 1959. (HMSO, R. Allen Brown)

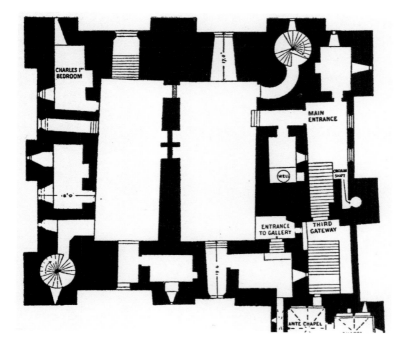

Interior plan of the second floor of the keep, 1959. (HMSO, R. Allen Brown)

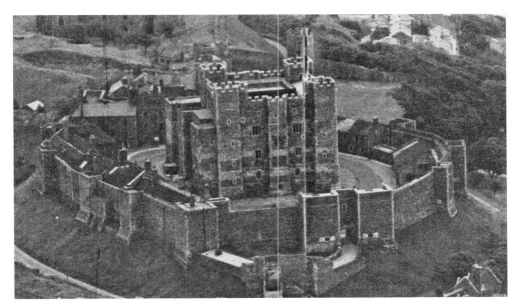

Aerial view of Dover Castle keep, 1959. You can just see the water tank on the roof. (HMSO, R. Allen Brown)

A 1960s view of the keep roof.

The keep roof undergoing rebuilding, 1994.

Suggested roof remodelling sketch with more authentic arrangement, c. 1994. (Richard Linzey)

Redoubt stood empty, derelict and slowly decaying. However, in 1993 English Heritage started a four-year conservation programme to repair all of the exterior brickwork on the inner ditch wall of the fort. This work began during the autumn of 1993 with the first site meeting being on 21 October. The remit for this work, as detailed in an English Heritage document dated 8 January 1993, was 'careful removal of artefacts from the floor of the moat surrounding the Drop Redoubt to safe storage within the Redoubt, repair and rebuilding where necessary of wall tops to revetment walls on both sides of the perimeter moat ... and possibly ... cladding the vaulted barracks building within the Drop Redoubt.'

The nature of this large conservation project meant that the English Heritage team and their contractors had to research the minutiae of every facet, including the design of the scaffolding, what mix of mortar to use in both warm and cold temperatures, what types of brick to use, how to move heavy pieces of stonework, negate vandalism, even the onsite Portaloo requirements and removal of ivy from the walls. Some of the brickwork was to be repaired using the plethora of abandoned (vandalised) bricks stockpiled within the Redoubt, and because the caponiers were built around fifty years later than the other inner ditch walls of the fort, two different types of brick were required. For the brickwork enthusiasts reading this, the Georgian brickwork was

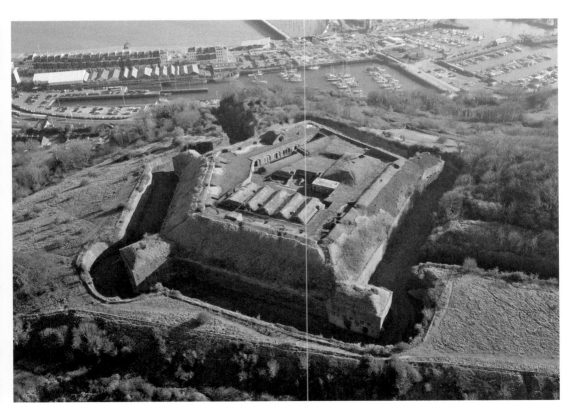

Drop Redoubt from the air, 2019. (Adam Cowell)

repaired using Tilmanstone Desimpel Buff stock dark, and for the caponiers, Smeed Dean Handmade. We even know that a flat-bladed quirk was used to prize away loose mortar. Because of budget constraints English Heritage made good use of a local jobs training centre where budding bricklayers received on-the-job training at the fort as well as in a classroom, while English Heritage provided the building specifications, materials, site set-up and equipment.

Typically at Western Heights, the building site suffered endless bouts of vandalism. I can remember going up there to see the progress made and to take photographs, and seeing tools strewn everywhere and scaffolding pulled down. It must have been disheartening for the workers there. Minutes from a site meeting held in November 1993 list twelve serious vandalism incidents in four months, including padlocks hacked off the main entrance, portaloos wrecked, the generator stolen, a water bowser tipped from the fort into the ditch, graffiti, damage to walls and ladders smashed. Given the type of work involved, the remote nature of the site and the cost it's a wonder they didn't give up. Over the four-year period, in excess of £200,000 was spent by English Heritage on repairing and conserving the inner walls of the ditch. Given the nature of the work, its logistical challenges and the vast sums of money required, the rest will have to wait for another day.

Entrance to the Drop Redoubt prior to conservation work by English Heritage, November 1997.

Less than a year later during conservation work by English Heritage, May 1998.

Above and left: Drop Redoubt ditch with scaffolding during conservation work, October 1998.

7. 'Expecting to be Raised with the Dust'

We have already seen how some unfortunate souls met their end at Western Heights, not very far from the Drop Redoubt. George Carey was an ordinary soldier in the 47th Regiment, Daniel Doherty belonged to the Donegal Militia and Thomas James was a simple excavator who was buried by an immense amount of earth. At the other end of the military spectrum were officers and 'gentlemen' who died while on service or through old age. One 'very model of a modern major general' was Major-General James Lawson, who died at Dover in April 1896. He was born at Edinburgh in 1831, privately educated and obtained a commission in the 17th Foot Regiment, to which he was posted in 1851. He later exchanged into the 59th Regiment, eventually becoming lieutenant-colonel, and was involved in the taking of Canton, China, during the Second Opium War. He later served in India during the Mutiny of 1857 and in Afghanistan. The major-general and his wife, Sarah, lived at Winchelsea Crescent on Folkestone Road with their daughter, Nora, and two servants, and he is buried in St James' Cemetery.

Another impressive name to be found there is that of Colonel Fitzwilliam Thomas Pollok. In the thirty years prior to 1878 he advanced up the ranks from ensign to colonel. However, lest we should speak ill of the dead, in 1891 the *Times* reported his bankruptcy, and also his 'departure from his dwelling-house with intent to defeat and delay his creditors'. In other words, he absconded. To make matters worse, his son, Herbert Charles Pollok, was sentenced to four years hard labour for 'obtaining and communicating information useful to an enemy' in Malta in 1934. In essence spying. The colonel died on 12 November 1909.

The last officer to be mentioned here is Lieutenant-General George Sandys, who died on 20 October 1864, aged sixty-seven. He was an officer in the Indian army, and colonel of the 6th Madras Light Cavalry. He lived at No. 6 Waterloo Crescent, which at the time of writing appears to be an empty building divided into flats. The Madras Light Cavalry was part of the Madras Army, which was one of three 'presidencies' making up British India in the nineteenth century. The other two were Bombay and Bengal, which up until the Indian Mutiny of 1857 ruled large areas of British India on behalf of the East India Company. After the Government of India Act 1858, the presidencies were responsible directly to the British Crown. The Sandys family is connected to aristocracy and the family seat is Graythwaite Hall in Ulverston, Cumbria.

These three military men are just a small sample of the interesting characters that have been interred at St James' Cemetery over the years, and perhaps might encourage one to go and investigate further.

The headstone of Major-General James Lawson, who died at Dover in April 1896.

Colonel Fitzwilliam Thomas Pollok, who is buried at St James' Cemetery, 2019. (*Wild Sports of Burma and Assam* by Pollok, Fitzwilliam Thomas (Thom, W. S, London, 1900))

The uniform of a 'sowar', or rider, in the 6th Madras
Light Cavalry, c. 1840.

There is another, much older cemetery in Dover, barely remembered these days. It is
hidden by dense tree growth at the foot of Western Heights on what is now a piece of
scrub land off Channel View Road. It was probably last used in 1842 but was originally
purchased by the Dover Corporation in 1665 as a burial ground for victims of the
bubonic plague. Europe's first major outbreak of the Black Death was in 1347 when the
disease reached Italy from Central Asia. It took hold in England the following year and
lasted until 1349, probably killing off one third of her population. Notwithstanding the
ever-present threat and regular resurgence of the plague in the ensuing three centuries
or so, there was not to be another catastrophic outbreak of the disease in England until
1665. On this occasion it was thought to have been 'imported to us from Holland, in Packs
of Merchandice; and if any one pleases to trace it further, he may be satisfied by common
Fame, it came thither from *Turkey* in Bails of Cotton or Silk, which is a strange Preserver
of the pestilential Steams.'

According to William Batcheller's 1828 guide to Dover, this outbreak of plague was
brought from London by 'a young person, who had been employed in that metropolis
as a servant'. On 4 August 1665 records note that 'the town is free from infection. One
house was visited [by plague] and five died, but none since'. A few days later Dover was
still free of plague, and on 12 August, the town is still clear but 'one house is shut up in
it'. Also a house was shut up in Eastry, one in Sandwich and seven in Canterbury where
a few had died.

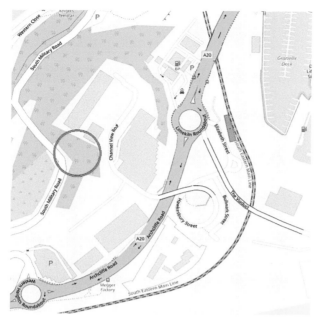

The red circle shows the position of The Graves at Archcliffe, *c.* 2018. (OpenStreetMap Contributors)

Copper engraving of Dr Schnabel (i.e. Dr Beak), a plague doctor in seventeenth-century Rome, *c.* 1656.

The practice of shutting up houses during a plague epidemic could indicate one of two things: the infected were legally obliged to be 'shut up' in their houses for forty days along with their relatives or whomever they lived with, healthy or not, in an effort to control the spread of disease. Houses that were shut up were marked with a red cross on their front door and 'Lord Have Mercy Upon Us' painted on them. Watchmen were employed to make sure that these houses stayed secure. During the plague, if they could afford it, townsfolk would leave for the countryside where it was considered to be safer, leaving their houses 'shut up' safely for their return.

In the seventeenth century no one knew where the plague came from and how it was spread, let alone how to control the contagion. We now know that the plague bacteria Pasteurella pestis bacillus was transmitted to humans by the flea *Xenopysylla cheopis* which lived on black rats. Simply put, with the death of the flea's host, the rat, it would look for a replacement host, and this was man.

On 2 October 1665 it was reported that in Dover 'the sickness increases, 20 houses are shut up' and by the 15th there were alleged to be twenty-four houses shut up and that additionally 'there is an increase at Sandwich; but Canterbury is free, as also Deal,

The Pest House and Plague Pit in Finsbury Fields.

Wood engraving of the pest house and plague pit, Moorfields, London, *c.* 1666. (Wellcome Collection)

Certain neceſſary

DIRECTIONS,

As well for the

CURE

OF THE

PLAGUE,

As for preventing the

Infection:

WITH

Many eaſy MEDICINES of ſmall
Charge, very profitable to His
Majeſty's Subjects.

Set down by the College of Phyſicians.

By the king's Majeſty's ſpecial Command.

—————

LONDON, Printed 1665: And Re-
printed at *Edinburgh* 1721.

Certain necessary directions, as well for the cure of the plague, as for preventing the infection, 1721.

Ashford, Maidstone and Sittingbourne.' By the beginning of November Deal 'still keeps free of the pestilence' but 'one person has died at Canterbury of the plague.' A few days later at Canterbury 'two persons have died of the plague this week through their own covetousness, one in posting to London and bringing down goods from infected places, and the other in sending for goods.' By 12 November the situation in Sandwich was worsening. For the first half of 1666 Dover is not mentioned in official records, so perhaps the disease had abated some, but by 21 June, Deal was infected: 'the sickness has increased so much that several have removed their families to Walmer.' Very differently to today, there would have been clear countryside between the two towns.

By 6 July Dover was declared plague-free, yet no communication was allowed with the folk of Deal, where the situation was going from bad to worse: 'the distemper is very violent at Deal, sweeping away whole families ... scarce any house is clear from infection'. By July 18, the plague was back in Dover and the situation worsening in Deal. 'The distemper in Deal much increases. It scarce leaves above one in a family ... at least 400 have died in Deal in 5 weeks.' By August news of the plague in France noted that 'the sickness is much at Boulogne' along with news nearer to home, noting that things were 'very sad at Deal, and of late has broken out much at Dover'. The lot of Dover seems to have fluctuated quite a bit during August 1666. Contemporary reports state that 'only one person died in Deal yesterday and none in Dover' and in just four days' time '10 died of the plague in Dover yesterday: is removing a little out of town' to a week later, 'the sickness increases daily at Dover.' By 27 August, Walmer looked like it might soon be clear of the disease, with the news that 'now most [people] live and have sores.'

Similar reports about Dover continue throughout the year, one of them noting that between 8 September and 15 September, 150 had died and ninety-six houses were still shut up. At last during early December it was reported that 'the townsmen of Dover are returning to their houses, which they left in the plague,' and on the 23rd two had died. With no further reports we have to assume that the plague had indeed run its course at Dover.

The cemetery at the foot of the Western Heights has for centuries just been known as 'The Graves'. It is located opposite P&O House, to the west of the site of the Western Heights Military Hospital that used to stand nearby (c. 1803–1962). The general concensus seems to be that around 900 'poor souls' were buried at The Graves during the plague. 'The bodies of these unhappy sufferers were in general carried from the pier in carts, some few in coffins, but most without.'

Today, The Graves is a densely wooded area that is difficult to navigate and it is impossible to discern that anything important ever happened there. During an archaeological assessment in 1992 the town's archaeologist Keith Parfitt recorded, among other things, that there are two brick vaults on the site, one of which has collapsed, both probably of eighteenth- or nineteenth-century origin. He also recorded the existence of a headstone bearing the names of Michael Becker (d. 1796) and Peter Becker (d. 1842). This has been removed to Dover Museum.

The 1665 plague outbreak cost London upward of 68,596 people, approximately 15 per cent of an estimated population of 460,000. The population of Dover at this time is unknown.

The possible remains of a brick burial vault at the plague pit at Archcliffe, known as 'The Graves', 2019.

I shall conclude the account of this calamitous year therefore with a coarse but sincere stanza of my own, which I placed at the end of my ordinary memorandums the same year they were written:

A dreadful plague in London was
In the year sixty-five,
Which swept an hundred thousand souls
Away; yet I alive!"[26]

26 Defoe, D., *A Journal of the Plague Year.*

Epilogue

'Soon full darkness would spread its concealing canopy over the old Cinque Port of Dover, over its Castle and Harbour, over men who, in the name of liberty, would ever faithfully defend their priceless heritage.'[27]

27 Armstrong, T., *Dover Harbour* (Collins, London, 1947), p. 576.

Bibliography

Allen Brown, R., *Dover Castle* (HMSO, London, 1979).

Ancestry.com.

Armstrong, T., *Dover Harbour* (Collins, London, 1947).

Asimov, I., *The Birth of the United States, 1763–1816* (Dennis Dobson, London, 1974).

Atherton, G. M., *Soldiers of the Castle, Dover Castle Garrisoned* (Triangle Publications, Dover, 2003).

Banks, Sir Donald, KCB, DSO, MC, TD, *Flame Over Britain, A Personal Narrative of Petroleum Warfare* (Sampson Low, Marston & Co. Ltd, London, 1946).

Batcheller, W., *A Descriptive Picture of Dover; or, the Visitor's New Guide* (King's Arms Printing Office, Dover, 1843).

Batcheller, W., *A New History of Dover and of Dover Castle during the Roman, Saxon and Norman Governments, with a Short Account of the Cinque Ports* (Dover, 1828).

Bavington Jones, J., *Annals of Dover* (*Dover Express*, Dover, 1938).

Beckett, Ian F. W., *Riflemen Form: A Study of the Rifle Volunteer Movement 1859–1908* (Pen & Sword Military, South Yorkshire, 2007).

Beevor, A., *The Second World War* (Weidenfeld & Nicolson, London, 2012).

Bowen, E., *The Heat of the Day* (Penguin, London, 1976).

British Medical Journal, various dates and volumes.

Brown, M., et al, *The Western Heights, Dover, Report No. 3: The Drop Redoubt 19th Century Artillery Fortification* (English Heritage, 2001).

Bucknall, R., *Boat Trains and Channel Packets: The English Short Sea Routes* (Vincent Stuart Ltd, London, 1957).

Burridge, D., *20th Century Defences in Britain: Kent* (Brassey's, London, 1997).

Burridge, D., *A Guide to the Western Heights Fortifications, Dover* (Kent Defence Research Group, Dover, 2002).

Burridge, D., *The Dover Turret, Admiralty Pier Fort* (North Kent Books, Rochester, 1987).

Chicago Daily Tribune, various issues.

Coad, J., & P. N. Lewis, 'The Later Fortifications of Dover', *Post-Mediaeval Archaeology*, 16 (1982) 141–200.

Coad, J., *Dover Castle and the Defences of Dover* (Batsford, London, 1995).

Dinorben Griffith, M., 'Illustrated Interviews. Miss Marie Hall, The Girl Violinist, A Romance of Real Life', *The Strand Magazine*, Vol. XXV January to June, George Newnes, 1903.

Dover Express, various issues.

Foster, R., *Dover Front* (Secker & Warburg, London, 1941).

Freedom of Information request – Dover Castle Keep Roof, Ref 18/00633, January 2019.

Freedom of Information request – Drop Redoubt Repointing, Ref 09/1331, December 2009.

Green, M. A. E. (Ed.), *Calendar of State Papers, Domestic Series, Charles II. 1665–1666, Preserved in Her Majesty's Public Record Office* (London, 1864).

Hasted, E., *The History and Topographical Survey of the County of Kent*, second edition, volume 9 (Canterbury, 1800).

Higgins, H. V. (ed.), *Opera at Home* (The Gramophone Company Ltd, London, 1921).

Hogg, I., *Coast Defences of England and Wales, 1856–1956* (David & Charles, London, 1974).

Hutchinson, W. (ed.), *Hutchinson's Pictorial History of the War* (Adam & Charles Black, London, 1940).

Ketchum, R. M., *Saratoga, Turning Point in America's Revolutionary War* (Pimlico, London, 1999).

Lester, H. F., The Taking of Dover, 1898, in *The Tale of the Next Great War 1871–1914*, Clarke, I. F. (ed.) (Liverpool University Press, 1995).

Lowry, Bernard (ed.), *20th Century Defences in Britain, An Introductory Guide* (Council for British Archaeology, York, 1995).

Macdonald, L., *The Roses of No Man's Land* (Penguin, London, 1993).

Moore, D., *A Handbook of Military Terms* (The Palmerston Forts Society, 1996).

Morris, T. A., *European History 1848–1945* (Unwin Hyman, London, 1995).

Morrissey, B., *Saratoga 1777, Turning Point of a Revolution* (Praeger, London, 2004).

Muir, Richard, *Castles & Strongholds* (Macmillan, London, 1990).

Myers, A. R., *England in the Late Middle Ages* (Penguin, 1991).

Parfitt, K., *The Danes, Old Charlton Road, Dover, Archaeological Walk-over Survey and Desk-top Study* (Canterbury Archaeological Trust, Dover, 2017).

Pattison, P., *The Western Heights Dover, Kent, Report No 7: North Centre and Detached Bastions: 19th-Century Fortifications* (English Heritage, Swindon, 2003).

Philp, B., *The Excavation of the Roman Forts of the Classis Britannica at Dover, 1970–1977* (KARU, Dover, 1981).

Pollok, F. T., & Thom, W. S., *Wild Sports of Burma and Assam* (London, 1900).

'Proceedings at the Meetings of the Archaeological Institute', *Archaeological Journal*, 13:1, 81–105 (1856).

Radford, Raleigh, C. A., *Dover Castle* (HMSO, London, 1959).

Ruddock, F. Mackay (1970) 'The Admiralty, the German Navy, and the Redistribution of the British Fleet', *1904–1905, The Mariner's Mirror*, 56:3, 341–346.

Sadie, S. (ed.), *The New Grove Dictionary of Music and Musicians*, second edition, vol. 25 (Macmillan, London, 2001).

Schenk, P., *Invasion of England 1940, The Planning of Operation Sealion* (Conway Maritime Press, London, 1987).

Schwartzman, A., *Phono-Graphics* (Chronicle Books, Canada, 1993).

Scholes, P. A., *The Mirror of Music, 1844–1944*, vol. 1 (Novello & Co. and Oxford University Press, London, 1947)

Scott, M., *Medieval Europe* (Longmans, 1964).

Tully, P., 'Ladies of Low Repute – Part 2', *Classical Recordings Quarterly, Summer 2013*, Issue 73, 18–24.

Waugh, E., *Vile Bodies* (Penguin, London, 1996).

Whitstable Times and Herne Bay Herald, various issues.

Defoe, D., A Journal of the Plague Year, Gutenberg.org, https://www.gutenberg.org/files/376/376-h/376-h.htm <Accessed March 7, 2019>

'Gramophone Catalogue', Musikaren Euskal Artxiboa Archivo Vasco de la Musica, 'Catalogue of Gramophone 7 Inch recordings', 1903, http://www.eresbil.com/opac/abnetcl.exe/O7023/ID5258123f/NT1 <Accessed November 25, 2018>

'Gramophone Record Catalogue 1899', British Library, https://sounds.bl.uk/related-content/TEXTS/029I-GRAGX1901XXX-0000A0.pdf <Accessed November 25, 2018.

Music Web International, http://www.musicweb-international.com/hooey/hyde-bio.htm, <Accessed November 25, 2018>

Opera Scotland, http://www.operascotland.org/person/3906/Edna-Thornton, <Accessed November 19 2018>

'Saturday, 29 March 2014, Being topical', http://fluffontheneedle.blogspot.com/2014/03/being-topical.html <Accessed November 17, 2018>

The Encyclopaedia of Science Fiction, Lester, Horace Frank,
http://www.sf-encyclopedia.com/entry/lester_horace_frank <Accessed January 13, 2019>

Volunteers During the First World War, The Red Cross, https://vad.redcross.org.uk/Volunteers-during-WW1 <Accessed 10 November 2018>

Western Heights Today, The Dover Garrison,
http://www.members.tripod.com/JeffHowe/dover_garrison.htm <Accessed January 3, 2019>